HERBLOCK

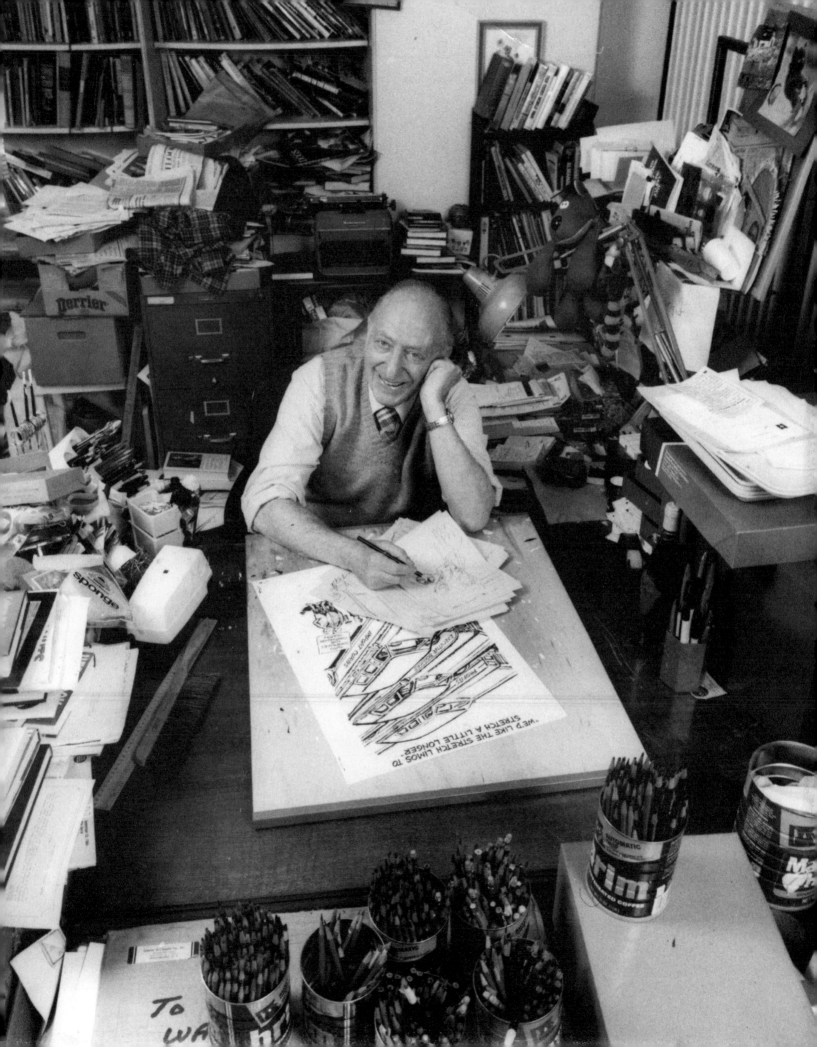

HERBLOCK

THE LIFE AND WORK OF THE GREAT POLITICAL CARTOONIST

For DeG and Max
Best wishes

Haynes Johnson

— AND —

Harry Katz

— PUBLISHED BY —

THE HERB BLOCK FOUNDATION
AND THE LIBRARY OF CONGRESS

IN ASSOCIATION WITH

W. W. NORTON & COMPANY
NEW YORK | LONDON

Herblock: The Life and Work of the Great Political Cartoonist
Haynes Johnson and Harry Katz

Book design and composition by John Bernstein Design, Inc.
Manufactured by Courier Westford

Library of Congress Cataloging-in-Publication Data

Johnson, Haynes Bonner, 1931–
 Herblock : the life and work of the great political
 cartoonist / Haynes Johnson and Harry Katz. — 1st ed.
 p. cm.

ISBN 978-0-393-06772-9 (hardcover)

1. Block, Herbert, 1909–2001.
2. Cartoonists—United States—Biography.
I. Block, Herbert, 1909–2001. II. Katz, Harry. III. Title.
IV. Title: Life and work of the great political cartoonist.

NC1429.B625J65 2009
741.5'6973–dc22
[B]
 2009029897

Photo credits: page 2, Doree Lovell; page 10, Time & Life
Pictures/Getty Images. Photo by R. Morse; page 36,
Time & Life Pictures/Getty Images. Photo by R. Morse;
page 58, Doree Lovell; page 271, photographer unknown;
page 298, Doree Lovell.

W. W. Norton & Company
500 Fifth Avenue, New York, NY 10110
www.wwnorton.com

W. W. Norton & Company Ltd.
Castle House, 75/76 Wells Street, London, WIT 3QT

1 2 3 4 5 6 7 8 9 0

Contents

Preface

From the stock market crash in 1929 through the new millennium beginning in the year 2000, editorial cartoonist Herbert L. Block, widely known as Herblock, chronicled the nation's political history, caricaturing thirteen American presidents from Herbert Hoover to George W. Bush. He received three Pulitzer Prizes for editorial cartooning (1942, 1954, and 1979) and was cited in the *Washington Post*'s Pulitzer for public service during the Watergate investigation (1973). He was elected a fellow of the American Academy of Arts and Sciences and in 1994 he received the Presidential Medal of Freedom.

In 2000 the Library of Congress named Herblock a "Living Legend" in recognition of his extraordinary contributions to the nation. Numerous honorary degrees from institutions nationwide, among them a Doctor of Arts from Harvard University, suggest academia forgave him for leaving college early to pursue a career as an editorial cartoonist. And well it should have, for no cartoonist or commentator in America did more to educate and inform the American public than Herblock. Political cartoons represent the freedom of expression inherent in American democracy, a powerful symbol of its strength and resilience. In the new millennium Herblock's drawings forcefully bring back the principal issues and events that shaped our world during the past century. Facing today's challenges, we lament the loss of his ever bright outlook and constant confidence in the will and wisdom of the American people.

Now, upon the centennial of his birth in 1909, it is my great pleasure, as his friend and admirer, to present this magnificent retrospective volume, copublished by the Herb Block Foundation and featuring commentary by Herblock's longtime colleague, the Pulitzer Prize–winning journalist Haynes Johnson. The book accompanies a Library of Congress exhibition displaying one hundred original Herblock drawings and sketches selected from the Herb Block Foundation's 2002 gift of the cartoonist's entire personal and professional archives, spanning seventy years of world history and the astonishing breadth of his distinguished career. No American cartoonist has influenced so many in their profession, their government, their nation.

The sign of a great cartoonist is the ability to effect change, and Herblock influenced politicians and altered public opinion throughout his career. He coined the phrase "McCarthyism," challenging the excesses of the anticommunist campaigns of the late 1940s and early 1950s. He followed Richard Nixon's political path from his House of Representatives reelection campaign in 1950 to his resignation as president of the United States in 1974. He documented the Cold War from its inception after World War II to the collapse of the Soviet Union in 1991. Furthermore, his numerous powerful cartoons on poverty, race relations, and education not only express his personal commitment to civil rights but measure over time the nation's response to such issues.

In tens of thousands of drawings published in newspapers over many years Herblock offered thoughtful graphic commentary on virtually every notable incident and public

figure from the Great Depression forward, portraying our history from his prescient, sometimes tragic, often funny, and always intelligent perspective. His drawings became his legacy, a monumental contribution to the profession of journalism and to future understanding of the times in which we live. The Library of Congress takes great pride in preserving them for posterity on behalf of the American people.

JAMES H. BILLINGTON *Librarian of Congress*

"What's This About Your Letting the Common People Come in Here and Read Books?"

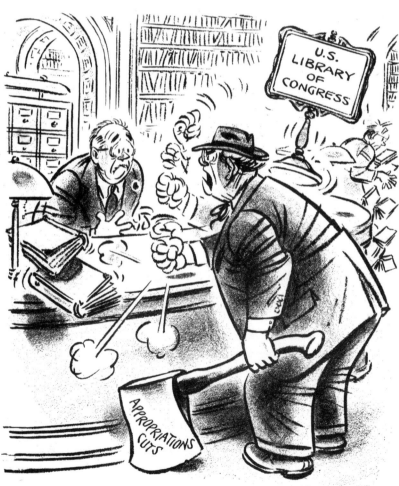

HERBLOCK
©1954 THE WASHINGTON POST CO.

June 6, 1954

THE Library of Congress was established by an act of Congress in 1800 providing for "such books as may be necessary for the use of Congress …" The original library was destroyed with the Capitol by British troops in August 1814, then rebuilt around retired President Thomas Jefferson's personal library. The library's annual budget is subject to oversight by the Joint Committee on the Library, the oldest continuing joint committee of the U.S. Congress.

Foreword

For nearly a third of the nation's history since declaring its independence, Herbert Lawrence Block served as a conscience for America.

Better known as Herblock, the legendary editorial cartoonist championed the causes of the poor, attacked discrimination of all kinds, and took on the big guys of American politics from 1929 until his death in 2001. I had the great honor and the pure joy of working with Mr. B. (what we in the office called him) for over forty years.

Mr. B. put his money where his pen had been—pursuing social justice. His will called for the creation of a foundation. He spelled out its charter in broad strokes, but he left the precise compass points for its future direction to be set by the board of directors. He left $50 million to carry out the mission.

The result was the Herb Block Foundation, which began its work in 2002 and awarded its first grants in February 2004 and its first scholarships in fall 2005. Since then the foundation has awarded millions of dollars in grants. It has also awarded hundreds of scholarships in a program for financially needy community college students in the Washington, D.C., area. The program has awarded thousands of dollars in scholarships since its inception.

Barack Obama, speaking at a foundation event in April 2005, summed up Mr. B.'s philosophy of life this way: "Be a good citizen and think about the other guy."

Obama praised the foundation for continuing Mr. B.'s work. "Every day he touched his pen to paper, Herblock made a difference in this world, and I'm sure he's looking down with pride, knowing that every day you walk into the foundation you're doing the same," Obama said.

The foundation's mission statement has guided its operations since opening day:

> The Herb Block Foundation is committed to defending the basic freedoms guaranteed all Americans, combating all forms of discrimination and prejudice and improving the conditions of the poor and underprivileged through the creation or support of charitable and educational programs with the same goals.
>
> The foundation is also committed to providing educational opportunity to deserving students through post-secondary education scholarships and to promoting editorial cartooning through research.
>
> All efforts of the foundation shall be in keeping with the spirit of Herblock, America's great cartoonist, in his lifelong fight against abuses by the powerful.
>
> The foundation has created three grant categories to help fulfill the first part of the mission: Defending Basic Freedoms, Pathways Out of Poverty and Encouraging Citizen Involvement. Each category encompasses the goals expressed in Herblock's cartoons.

Most of Mr. B.'s cartoons are as relevant today as they were when he first drew them. For example, few cartoons reflect the "Defending Basic Freedoms" category as well as "Fire!" (see p. 115).

The 1962 cartoon "I'm Eight. I Was Born On The Day Of The Supreme Court Decision" —published upon the eighth anniversary of the

1954 *Brown v. Board of Education* ruling that ended public school segregation—demonstrates the intent of our "Pathways Out of Poverty" grants and our efforts to help the poor with education scholarships. In 1964 the cartoon ran again with "ten" for "eight" and once more in 1968 with "fourteen" substituted for "ten."

The foundation donated the complete Herblock archives to the Library of Congress, including more than fourteen thousand original cartoons. Part of Mr. B.'s desire was to make his work accessible to both scholars and the general public. He also wanted to help encourage young editorial cartoonists, in whatever format they might choose, to continue shining light into the dark corners of American society.

The foundation has established the Herblock Prize for editorial cartooning. The prize carries a tax-free cash award and a sterling silver trophy. It has become a major prize in the profession.

As Mr. B. once wrote, describing the work of editorial cartoonists, "Political cartoons, unlike sundials, do not show the brightest hours, they often show the darkest ones, in the hope of helping us to move on to brighter times."

Our goal is to continue moving on to brighter times.

JEAN RICKARD *Executive Director, Herb Block Foundation*

"I'm Eight. I Was Born On The Day Of The Supreme Court Decision"

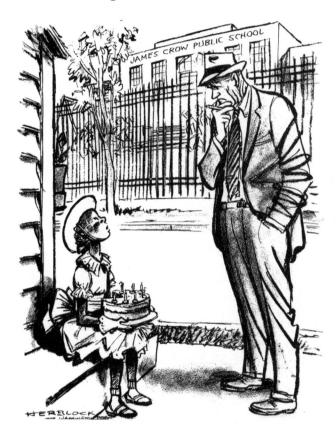

May 17, 1962

HERBLOCK was a champion of civil rights throughout his career. Eight years after the U.S. Supreme Court ruled unanimously that racial segregation in public schools was unconstitutional, in the 1954 case of *Brown v. Board of Education of Topeka, Kansas*, he penned this cartoon expressing his dismay at the country's slow progress toward educational integration.

HAYNES JOHNSON

The Age of Herblock

H E was just a boy, barely into grade school, when he drew his first caricature. Typically, the subject was not some childish rendering of a teacher, classmate, or sports hero. It was of the archvillain of the time, Kaiser Wilhelm, whose German legions had plunged the earth into World War I, setting in motion what became the bloodiest century in human history.

Typically, too, the boy didn't draw his caricature on a scrap of paper where no one could see it. "I did him in chalk on the sidewalk" outside his Chicago home, he recalled decades later. "With his W-shaped mustache, squinty eyes and spiked helmet, he was easy." What's more, he chose that public spot for a special reason: "People could see (and admire) my work; and I could feel satisfaction rather than injury when that hateful face was walked on or stomped on." And if passersby smeared the portrait, well, the boy had the great satisfaction of knowing "I could always do the Kaiser over again as long as the chalk held out."

The boy was Herbert L. Block, or Herblock, as the world came to know the most celebrated cartoonist of his time. With the possible exception of Thomas Nast, Herb, my longtime colleague, was America's greatest cartoonist. And Herb's work spanned a longer, more significant period than Nast's post–Civil War, nineteenth-century America. It also had a greater imprint on the widest range of American society. After his first childish caricature in that World War I period, Herblock's pen, if not his chalk, held out for the remaining decades of the twentieth century and into the twenty-first.

Day after day, year after year, decade after decade Herb indelibly depicted villains and rogues, corrupt officials and corporate polluters, racists and demagogues. He relentlessly attacked the gun lobby, segregationists, governmental secrecy, abuses of power, religious bigots, sexism, racism, and, always, public hypocrisy wherever and whenever it arose. At the same time he ardently fought for civil liberties, for the poor and the oppressed. He always stood for the underdog, and for the everyman and everywoman among us trapped in, or frustrated

by, the ever more complicated nature
of modern life.

He once expressed the range of
his personal peeves, those irritations
that provided him inexhaustible daily
material for his cartoons: "There are
the telephone solicitations; gatefold
ads in magazine covers; potholes;
tailgaters; litterbugs; blood-and-gore
'entertainment'; stores and restau-
rants that patronize their patrons, and
discourtesy anywhere; products
designed to conk out one week after
the warranty has expired; repair people
who go incommunicado when they are
due to arrive and make a mockery
of the phrase 'service economy'—and
how about the remote controls that
we can't seem to control?"

That's quintessential Herb. But
even more typical is another aspect of
his character that makes his work so compelling—and enduring.
As he said, "Most frustrating are the misdeeds and failures of
governments—*our* governments, *our* public servants—that infu-
riate us, the political outrages and scandals that make us want
to shout, 'They can't *do* that!' But there's the non-rub, the real
point, the place where I have it good. I have my own reserved
soapbox. I get to *say* it in published cartoons. And for creative
pleasure, the little black ink bottle contains everything from
a picture of a pompous politico down the street to a drawing of
planets swirling around in space. It's the ideal occupation—always
the same but always something new."

Hurry! Hurry!

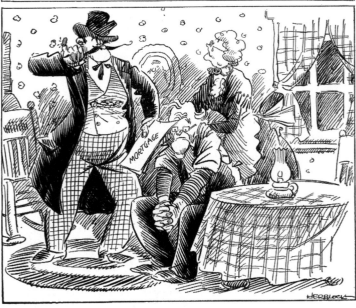

March 27, 1933

WITH banks failing and foreclosing on mortgages in
1933, Congress debated what could be done to help
homeowners. Herblock stressed the necessity for quick
action. Soon after this cartoon appeared, Congress estab-
lished the Federal Housing Administration, which
provided or insured mortgages, and the Federal Deposit
Insurance Corporation.

"It's Still A Representative Form Of Government—They Represent Us"

May 18, 2000

THE unlimited "soft money" raised by national party organizations can be spent on advertisements that skirt campaign finance reforms. Herblock consistently pointed out that skyrocketing campaign contributions and expenditures threatened "government by the people and for the people." He also said, "there is nothing free about sales of public office to high bidders, who buy and pay for elections and influence."

During Herb's long career he portrayed virtually all the major players on the world stage, infamous or otherwise: Adolf Hitler and Joseph Stalin, Benito Mussolini and Neville Chamberlain, Winston Churchill and Charles de Gaulle, Leonid Brezhnev and Nikita Khrushchev, Chiang Kai-shek and Douglas MacArthur, Mao Tse-tung and Ho Chi Minh, Mikhail Gorbachev and Ayatollah Khomeini, Francisco Franco and Fidel Castro, Josip Tito and Saddam Hussein, Charles Lindbergh and Huey Long, Al Capone and John Dillinger, Adlai Stevenson and Edward R. Murrow, Martin Luther King Jr., and Robert F. Kennedy, J. Edgar Hoover and Ollie North, Spiro Agnew and George Wallace, Sam Rayburn and Newt Gingrich, Father Charles Coughlin, Jerry Falwell and Pat Robertson. His work provides nothing less than an extended panorama of a grand sweep of history encompassing the best and worst of our times. His cartoons thus become a lasting record of the political, social, and cultural events that shaped the history of a tumultuous period spanning nearly three-quarters of a century.

From the stock market crash of 1929 that ushered in the Great Depression to the New Deal, from World War II through Vietnam, from the atomic age to the equally fearsome one of weapons of mass destruction and global terrorism, Herb chronicled it all. He also chronicled the actions of thirteen American presidents from Herbert Hoover to George W. Bush: Franklin D. Roosevelt and Harry Truman, Dwight D. Eisenhower and John F. Kennedy, Lyndon Johnson and Richard Nixon, Gerald Ford and Jimmy Carter, Ronald Reagan and George Bush the first, and, finally,

What 'Peace Now' Would Mean

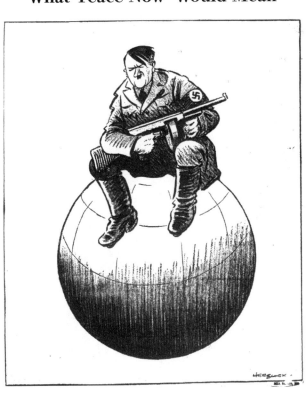

January 3, 1940

HERBLOCK opposed the appeasement of Nazi Germany and favored U.S. intervention to defeat fascism in Europe. By early 1940 Adolf Hitler had shown his military might and was bombing Britain nightly — signs that the world would be overcome by militarism and terror if the democracies failed to fight.

The Spoken Word

"When the time comes in 1940 when there is only one party and a dictatorship,
I shall be the one to ask you to put aside your ballots and use bullets."

"God's philosophy was to increase and multiply. Roosevelt's is decrease and destroy.
Therefore I call him anti-God and a radical."

— EXCERPTS FROM FATHER COUGHLIN'S CINCINNATI SPEECH

October 7, 1936

CATHOLIC preacher Father Charles Coughlin gained fame during the 1920s for his popular weekly radio broadcasts. He spoke out against Communism and greedy capitalists alike, stood up for workers receiving "a just and living wage" and, for the elderly, an early form of social security. He supported FDR's New Deal early on, but soon formed his own National Union of Social Justice Party that developed a platform incorporating elements of anti-Semitism and fascism.

Bill Clinton and George Bush the second. His trenchant characterizations of those presidents are now stamped in the public mind and memory, just as his depictions of their times in office, covering a fourth of all U.S. administrations, will endure. They provide a treasure trove for both historians and citizens seeking to understand the issues and the personalities that defined those eras.

When Herb finally laid down his pen he left an astonishing body of work: some twenty thousand editorial cartoons; ten books plus an autobiography; texts of speeches; and miscellaneous writings. He was honored and admired, feared and hated. He won three Pulitzer Prizes and was cited for his cartoons that contributed to the fall of Richard Nixon in a Pulitzer Prize won by the *Washington Post*. During his time he became the only living cartoonist whose work was exhibited in the National Gallery of Art, the only one to receive the Presidential Medal of Freedom. Among other honors he also was the cartoonist who, fittingly, was commissioned by the U.S. Postal Service to draw the image for the stamp commemorating the 175th anniversary of the United States Bill of Rights.

Longevity and multiple honors alone are not what make Herb's work so relevant in the America of the new millennium.

"It's The Speak-Loudly-and-Poke 'Em-With-A-Big-Stick Policy"

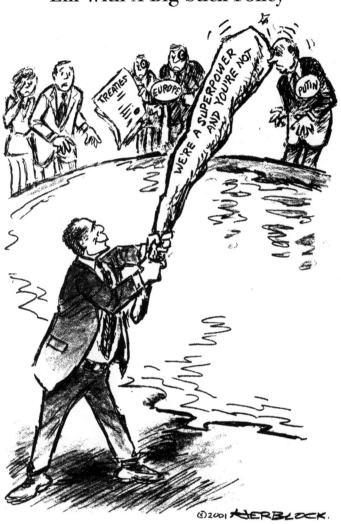

©2001 HERBLOCK.

August 26, 2001

HERBLOCK'S final cartoon criticized what he perceived as U.S. President George W. Bush's tendency toward unilateralism in American foreign policy. His satirical swipe alludes to President Theodore Roosevelt's appropriation of an African proverb to describe his approach toward foreign relations: "Speak softly and carry a big stick; you will go far."

His genius—yes, that overworked term applies in his case— captured, simply yet powerfully, the critical episodes that were shaping American and world life.

Herblock was far more than a mere chronicler of events; he had the rare talent of the great artist, the playwright, or the novelist that enables people to understand the significance of what was taking place as well as the stakes involved. Even more important, he had an uncanny ability to anticipate, and to influence, the forces transforming national life: the civil rights movement, the antiwar movement, the feminist movement, the environmental movement, the consumer movement. In all this he was the most prescient of national commentators.

Examples abound of his ability to call the turn of events; they leap out when you step back and examine the body of his work.

In the very early 1930s, for instance, as Hitler was on the rise, Herb's cartoons warned of the deadly menace the Nazi dictatorship presented to the world even before Hitler finally assumed power. When the spirit of appeasement reigned through-out Europe, when the United States was lost in isolationism and preoccupied with its internal affairs, Herb's cartoons repeat-edly tried to rally the world to act to check the threat of another world war. One of his cartoons then shows world leaders poised upon a ticking time bomb about to explode. His caption read: "The world as it looks right now." The date was 1934—five and a half years before Hitler launched his blitzkrieg into Poland, igniting the war that swiftly enveloped first the continent and then the entire world.

How Are You Coming Along With Your Work These Days?

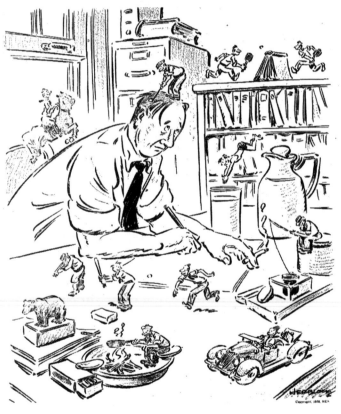

June 30, 1938

HERBLOCK'S self-portrait shows all the leisure activities a harried cartoonist would rather be pursuing.

The World as It Looks Right Now

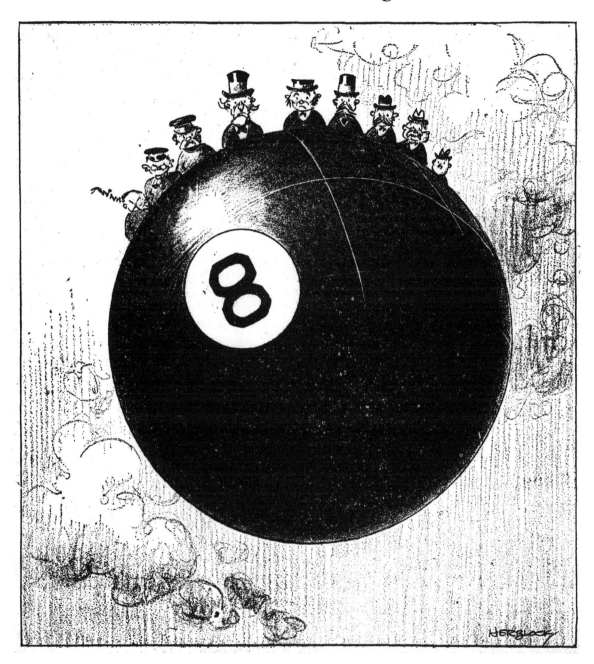

March 12, 1934

IN 1934, with Japan controlling parts of China and Hitler eradicating German democracy, Herblock recognized that militarism was replacing diplomacy as a tool for international relations. Figures representing the United States, the Soviet Union and other major powers are behind the eight ball, a vulnerable position from which the world is unlikely to avoid war.

In that same pre–World War II period, Herb turned his pen to another brutal dictatorship: Stalin's in the Soviet Union. In 1937, when Stalin began his infamous mass trials and executions, Herb drew a cartoon showing bound Soviet citizens gathered beneath huge dark hands holding an encircling hammer and sickle. Four years later, just before Hitler catastrophically invaded the Soviet Union, he showed the Führer atop a Nazi tank advancing toward a spectral figure of a defeated Napoleon huddled on his horse heading toward him from the opposite direction. "The

Under The Hammer And Sickle

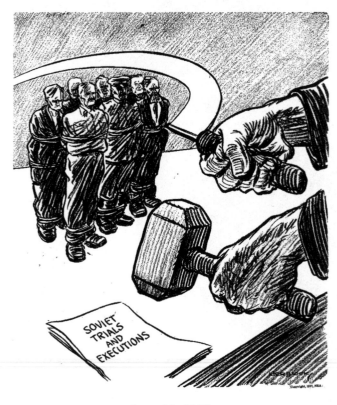

June 19, 1937

JOSEPH Stalin purged political enemies—everyone who protested or disagreed with him—from the Soviet state throughout the mid-1930s by exiling or executing them. Those purged often "confessed" to being anticommunist or "reactionary" at show trials. Some of the most famous were held in Moscow in 1936, 1937, and 1938.

The Road to the East

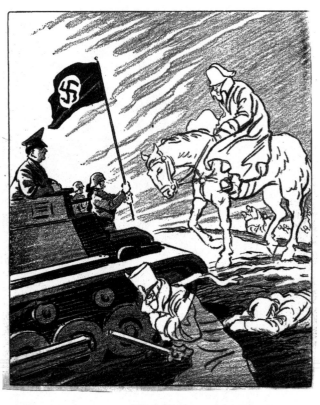

May 1941

ADOLF Hitler promoted increasing *lebensraum* ("living space") for the German people, setting his sites on conquering Eastern Europe and, eventually, the Soviet Union. Herblock's cartoon was drawn a month before June 22, 1941, when Nazi Germany surprised the Soviets by invading. Hitler intended a swift victory, but the Soviets mounted a successful resistance. The Germans were eventually forced to retreat, just as Napoleon had been defeated in his attempt to take over Russia some 150 years earlier.

road to the East," Herb's caption read. Nor did he ignore potential dictators at home. One of his strongest characterizations is of the demagogue Huey Long, ranting into a microphone while reading from a script labeled "every man a king"; before him, wrapped in chains, head sunk in despair, is the figure representing Long's state of Louisiana.

These, and countless more, are as fresh and vivid as when he drew them. The best example of Herb's talent for defining an era came in the immediate years following World War II. After the war's horrors and the dropping of the atomic bomb, suddenly, and seemingly overnight, hopes for a more peaceful era were cruelly dashed by fears of even greater calamities to come. It was a time when America's newspapers were filled with frightening reports of treachery, spies, communists, enemies within and without; a time when the Soviet Union and Communist China had formed a military alliance in opposition to the Western democracies; a time when a cold war was turning hot and everything seemed pointing toward a war of incalculable destruction through employment of terrible new nuclear weapons.

It was against this fearsome background that early in 1950 an obscure freshman Republican senator from Wisconsin named Joseph R. McCarthy was dispatched by party leaders to give a speech before a GOP women's group in Wheeling, West Virginia. McCarthy's trip was part of a Republican national election campaign strategy designed to label Democrats "soft on communism." In his speech McCarthy claimed—falsely—to hold in his hand a

The Crown Jewels

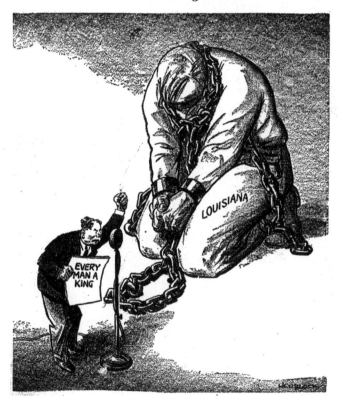

April 18, 1935

HUEY "Kingfish" Long (1893–1935), populist politician from Louisiana, died from an assassin's bullet in 1935. Admired by many for his ambitious programs to build roads, schools, and hospitals, he was also criticized for his autocratic domination of state politics as governor (1928–32) and U.S. senator (1932–35). During a 1935 Senate speech, he promoted his own "Share Our Wealth" program, promising to make "every man a king."

list of 205 Communist Party members who were part of a spy ring operating out of the U.S. State Department and traitorously shaping the foreign policies of the United States.

For days after his speech McCarthy kept escalating his charges of communist traitors within. He made more unsubstantiated charges—and drew greater headlines and attention— by accusing the highest leaders of the U.S., including Secretary of State Dean Acheson and President Harry S. Truman, of willfully being soft on Communism, if not being traitors themselves. An ominous age of character assassination, of guilt by association, of exploiting fear to gain political power had begun.

Only weeks after the Wheeling speech, readers of the *Washington Post* opened their papers to find an editorial cartoon by Herb. It showed Republican leaders pushing a reluctant GOP elephant toward a shaky tower fashioned of ten bespattered tar buckets, complete with tar brushes. At the very top, Herblock labeled the largest oozing bucket: *McCarthyism.* He had defined an era and created a term that quickly became a common noun in dictionaries where "McCarthyism" is defined as, first, "public accusation of disloyalty to one's country, especially through pro-Communistic activities, in many cases unsupported by proof or based on slight, doubtful or irrelevant evidence"; and second, "unfairness in investigative technique."

As hysteria over the Cold War intensified and American politics became more bitterly polarized, Herb continued to skewer demagogues such as McCarthy and others who made false accusations against fellow

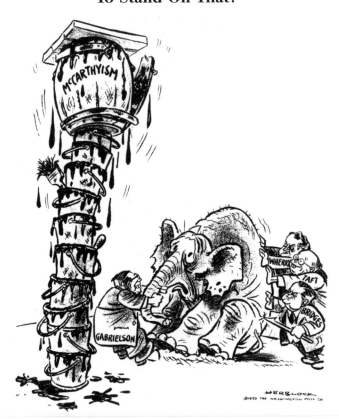

"You Mean I'm Supposed To Stand On That?"

March 29, 1950

THE word "McCarthyism" first appeared in this cartoon. In February 1950 Senator Joseph McCarthy captured headlines by claiming he had a list of Communists in the U.S. State Department. Many members of Congress began to support his tactics. Here conservative Republican senators Kenneth S. Wherry, Robert A. Taft, and Styles Bridges and Republican National Chairman Guy Gabrielson push a reluctant GOP elephant to mount the unsavory platform.

"It's Okay—We're Hunting Communists"

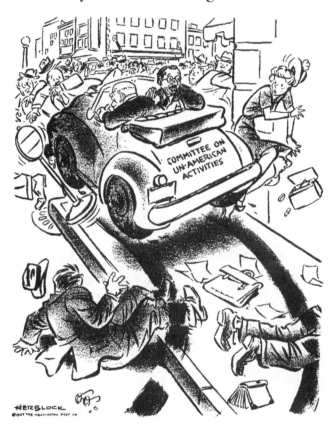

October 31, 1947

THE Cold War revived the anti-Communist hysteria that had gripped the U.S. following World War I. In 1947 Congress revived the House Committee on Un-American Activities (HUAC). Herblock disapproved of the way it threatened potential "suspects," demanding that they name their "leftist" associates, who would then name their associates in an ever-expanding list.

"I Have Here In My Hand—"

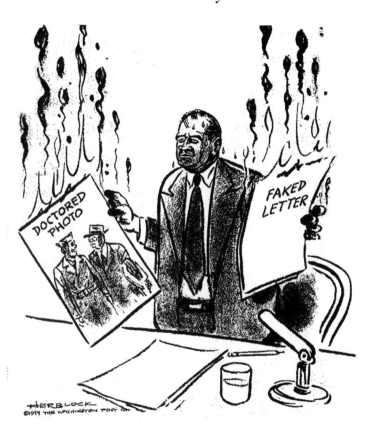

May 7, 1954

IN 1954, Senator Joseph McCarthy went too far when he accused the United States Army of promoting communists. The Senate held special hearings, known as the Army–McCarthy hearings, which were among the first to be televised nationally. Both the public and politicians became increasingly disenchanted with the bullying antics of the senator. McCarthy was censured by his colleagues for "conduct unbecoming a senator."

"Go Upstairs And Wash Your Hands"

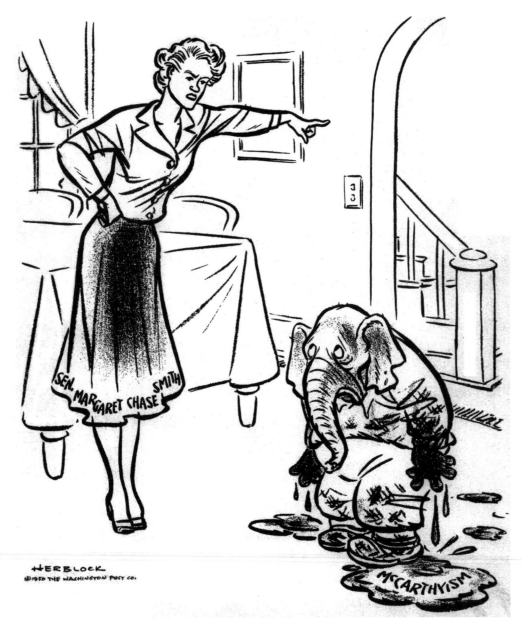

June 4, 1950

HERBLOCK admired Margaret Chase Smith, a moderate Republican senator from Maine, who had a distinctive place in Congress as a woman. On June 1, 1950, Smith gave a speech on the Senate floor chastising McCarthyism and the House Un-American Activities Committee. She defined the true "Americanism" as the right to criticize, hold unpopular beliefs, protest, and engage in independent thought.

citizens. Of those, none presented a greater target for him than Richard Nixon.

Herb's portrayals of Nixon began long before McCarthy mounted the national stage and continued for twenty-six years until Nixon was forced to resign in disgrace after Watergate.

You will not find a clearer picture of the Nixon presidency, from beginning to end, than that forever depicted in Herb's cartoons—or a greater demonstration of Herb's gift for prescience. Only days after the Watergate break-in on June 17, 1972, for example, Herb's cartoon showed the White House looming in the background while out front are lines of fresh footprints leading from and to the very doors of the executive mansion. Inspecting those telltale footprints, a man with a detective's magnifying glass says to a perplexed passerby, "Strange, they all seem to have some connection with this place."

By that time, Herb had become an institution—and a target of right-wing critics who labeled him as, at best, a dangerous left-wing liberal and, at worst, a communist conspirator himself.

To anyone who knew him, the accusations were absurd. He was an American patriot to his core. Yet Herb, the gentle person, could not be more different from Herblock, the hard-hitting cartoonist.

In 1996, on the occasion of his fiftieth anniversary at the *Washington Post,* Katharine Graham, its owner and publisher, paid tribute to him not only as "one of the greatest ornaments of the *Washington Post*" but "to all of journalism." Then she said, "Underneath his genius for cartooning and writing lies a modest, aw-shucks personality.

"Here He Comes Now"

October 29, 1954

RICHARD Nixon discovered the power of smear attacks in his early campaigns for the House of Representatives and Senate. In 1954, while campaigning for Republican candidates for mid-term elections, he traveled the country charging previous Democratic administrations and current Democratic members of Congress with being soft on Communism. Herblock's 1954 depiction of the emerging campaigner would stick with Nixon throughout his career.

Underneath *that* lies a layer of iron and steel. For the publishers and editors over him—or under him, as it would be more accurate to say—it's like having a tiger by the tail."

She told how "Herb fought for and earned a unique position on the paper: one of complete independence of anybody and anything," then added, "Journalistic enterprises run best when writers and editors have a lot of autonomy." Herb's career was proof of that proposition, and of her wisdom in granting him total freedom to express himself. It worked, as Kay Graham said, "because he's a genius" —and because she let his talent flourish even if, privately at times, she disagreed with what he had drawn.

What she didn't describe was how representative Herb was of the America in which he was born. He was not some effete, elite eastern snob from the liberal "mainstream media," as his critics labeled him and others, then and later; he was a child of the Middle West, whose Chicago contained probably the most common American characteristics: Chicago, the proud, the boastful, Carl Sandburg's swaggering city of the big shoulders; Chicago, meatpacker to the world, and of Al Capone; Chicago, the toddling town of the roaring twenties and of the rough-and-tumble irreverent journalism of the *Front Page*; Chicago, the city where Mayor William Hale Thompson's signature appeared on billboards underneath the jingoistic slogan: "Throw Away Your Hammer and Get a Horn. Boost Chicago." When the king of England visited America, that same mayor promised to "bust him on the snout" if the king dared to come to Chicago.

"Dr. Kissinger, I Presume?"

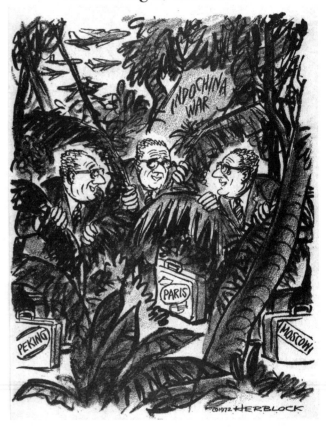

June 16, 1972

HENRY Kissinger, Richard Nixon's national security advisor, made détente with the Soviet Union and China and ending the Vietnam War foreign policy priorities. His negotiations, sometimes secret, took him to Peking (now Beijing), Moscow and Paris, where peace talks to cease hostilities in Vietnam took place. Détente with the Communist superpowers helped to foster the Paris Peace Accords signed in January 1973.

"Strange—They All Seem To Have Some Connection With This Place"

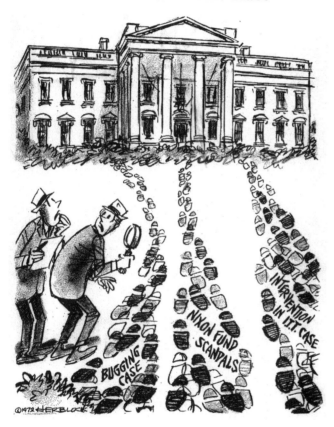

June 23, 1972

Wrong Number

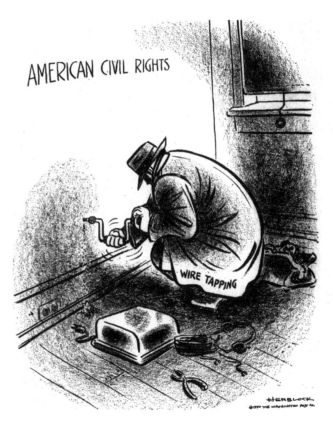

January 20, 1950

ON June 18, 1972, *Washington Post* staff writer Alfred E. Lewis reported the arrest of five men in an apparent attempt to burglarize and bug the Democratic National Headquarters at the Watergate building in Washington, D.C. The next day, two young *Post* reporters, Carl Bernstein and Bob Woodward, were assigned to the story and began their epic coverage. Herblock's cartoon, dated June 23rd, explicitly linked the burglary episode to the White House long before all the facts were known.

FORESHADOWING recent disclosures revealing overly aggressive electronic eavesdropping by intelligence agencies pursuing the war on terror, Herblock challenged illegal wiretapping of United States' citizens by government agencies for decades, from the anti-Communist witch-hunts of the 1940s and 1950s, through the Watergate scandal and Ronald Reagan years.

Compared to the terrors and trauma that were to come, for America and the world, Herb's boyhood occurred in a more innocent time that now hardly seems recognizable, or believable. It was a world in which there were no radios, no television, no jet planes, no space flights, no computers, no Internet, no iPods, no cell phones, no BlackBerries, no bloggers. Movies were black-and-white silent films. The stars of the day were Charlie Chaplin, Mary Pickford, Douglas Fairbanks, Pearl White, Mabel Normand, Wallace Reid. Herb's father, a remarkable person in his own right—chemist, inventor, former newspaper reporter who himself had a talent for writing and drawing—took the young boy and his elder siblings to those movies, to vaudeville shows, baseball games, and the touring Ziegfeld Follies, where they saw such stars as Will Rogers, Fanny Brice, and W. C. Fields.

As Herb later recalled of his boyhood pre–World War I days, "It was a time of hand-cranked Victrolas, autos and kitchen coffee grinders, of player pianos powered by the pumping of the feet, of washing done at tubs and hung up to dry in the back yard, of floor scrubbing, a time when the few electric appliances included fans that hummed on steamy summer days and nights. There was no cellophane, plastic or widespread pollution—but also no penicillin, no 'pill,' no by-pass surgery, none of the hundreds of innovations generally described as the greatest thing since sliced bread—and no sliced bread either. Bread came in loaves that smelled good in bakeries and even better in the kitchen oven when we came home from school. If the phone and telegraph were the only means of instant contact, there were other forms of communication—at least six or seven newspapers in Chicago, two mail deliveries a day (without junk mail) and special delivery that *was* special delivery....Trolleys, and later buses, had two-man teams—motorman and conductor. Horses were still on the streets, pulling postal wagons, milk wagons, junk wagons, ice wagons. A card in the kitchen window with large numbers printed on the sides let the iceman know whether he was to carry up to 25, 50 or 100 pounds. Notes in empty milk

bottles told the milkman what to leave."

Whatever political differences existed then, and however many problems from political corruption to gangster slayings marked the period, Americans had a passionate belief in their country's greatness. They were optimistic, convinced that the Americans of tomorrow would lead better lives than those of today, confident there were no problems they couldn't overcome, expose, and correct. One of Herb's lasting memories was of how his grade school let out—twice—to celebrate the armistice ending the first world war, which was hailed as, and believed to be, "the war to end all wars." He remembered, too, how his father took the family downtown that night to stand amid the cheering Chicago crowds jamming the streets.

While the mystery of extraordinary talent, to say nothing of genius, remains virtually unfathomable, in Herb's case he clearly was marked as special from the beginning.

As a boy he was always sketching and "splashing around in watercolors" at his drawing board at home. His father encouraged him, bringing him drawing materials and art books. By the age of eleven he was enrolled in the Art Institute of Chicago. Within a year he won a scholarship to study for another term. Already, he was attracting notice. The papers carried an item about the "youngest-ever scholarship winner." He began to win more prizes in such contests as "write-a-title" and "comic coloring" for kids run by the local Hearst papers. More headlines followed: BOY ARTIST WINS AGAIN.

In high school, he drew cartoons and wrote a column for the school paper. They began to be picked up for publication in the *Chicago Daily News* in weekly sections reprinting selections from school students. Editors spotted, and encouraged, him further. He began submitting paragraphs for publication, sometimes two a day. When he thought about a byline for his paragraphs his father suggested: Why not combine your first and last names? So was born Herblock, which became the signature for his articles and his cartoons from then on.

Journalism beckoned. Not only had his father been a reporter but his older brother, Bill, was a top reporter for the *Chicago Tribune*. When Herb graduated from high school, at age sixteen, he got a job as a police reporter for the Chicago City News Bureau. Salary: $12 a week. Before entering nearby Lake Forest College, he had begun drawing cartoons for a suburban paper, the *Evanston News-Index*. He also drew for, and was paid by, local Republican Party organizations. In view of the later accusations that he was nothing but a polemicist for liberal Democrats and their party, Herb delighted in explaining why he had begun by taking money from GOP organizations that had commissioned his drawings for them: "Drawing for the Republicans involved no sacrifice of principle because, in the best of all possible worlds, everything, including the party in office, was fine." Besides, as he would say, the Republican Party had been the party of the great nineteenth-century cartoonist Thomas Nast, whose profusely illustrated biography had made a tremendous impression on him. Not only that, Herb was strongly influenced by the GOP support from a contemporary conservative cartoonist, Jay Norwood "Ding" Darling, "an idol whose work I followed closely." Herb's father also supported Republicans, though he, like his son, never voted a straight party line ticket. The Blocks were what today we'd call independents.

Toward the end of his second year in college, he took some of his cartoons from the Evanston paper to the *Chicago Daily News* in hopes of getting a summer job. A few days later he was phoned and asked to come back. An editorial page cartoonist was leaving the city. Would he be interested in trying out for the job? An editor had seen his published column contributions in the rival *Tribune* and he was impressed. "Well," he said to the aspiring cartoonist, "you don't seem to have any trouble coming up with ideas."

In all the years to come, Herb regarded that call as the luckiest break he could have had. He started work immediately and never went back to school.

At that time, Chicago daily journalism teemed with talent, and the *Daily News* was home to such legendary figures as

Robert J. Casey and Ed Lahey, as well as boasting a great foreign service rivaled only by the *New York Times*. When Herb joined the staff one of the young reporters was Mary Walsh, who became a successful writer herself and later met, married, and ultimately became the widow of another Chicago journalist and novelist, Ernest Hemingway. Years later, when Herb happened to meet her at a party, she began talking about their old days on the *Daily News*. "I realized she was the same Mary Walsh I used to see in the news room," Herb recalled.

Occasionally, Herb would submit cartoons to the publisher, Colonel Frank Knox, a bright-eyed man who wore pince-nez glasses and had a wide smile. Knox was a lifelong Republican who had served in Cuba with Theodore Roosevelt's Rough Riders and became one of TR's ardent Bull Moosers. Later, he sought the Republican presidential nomination and in 1936 became the vice presidential choice on the Republican ticket of Alf Landon. Still later, Franklin Roosevelt made him his secretary of the navy, one of many prominent Republicans FDR brought into his cabinet to serve during World War II.

The Colonel, as he was called, became an admirer of young Herb's cartoons, along with many others. One day, upon returning from lunch, Herb found a piece of copy paper on his desk. On it, written boldly in black copy pencil, the note read: "Dear Herblock—Your 'Corn-Husking Champ at home' is the finest cartoon I ever saw."

It was signed "Carl Sandburg," the great poet, historian, and Lincoln biographer then writing a weekly column for the paper. The young cartoonist raced down the hall to Sandburg's cubicle to introduce himself and thank him. Then he took the treasured sheet of copy paper home to show his parents. The copy paper was promptly framed; he and Sandburg became lifelong friends.

Other national papers began picking up his cartoons. They were also regularly reprinted in the *Literary Digest*. By the end of the Hoover administration, the Newspaper Enterprise Association (NEA), put out by Scripps-Howard, asked Herb to

draw some cartoons for the association. Fine, Colonel Knox told him. Then NEA offered Herb its main editorial cartooning job for the syndicate, based in Cleveland. "I told Knox about it again," Herb remembered, "and he was warmly approving."

"You want your place in the sun," Knox told Herblock. Herblock thanked the old Bull Mooser and took the new job. At the beginning of 1933, and of a new presidential administration headed by Roosevelt, he moved to Cleveland. For the next decade, as the world hurtled from depression to world war, Herb's syndicated cartoons attracted even greater attention for the way he portrayed FDR's New Deal, the Great Depression, and the gathering storm of global conflict. It was during that period that he won his first Pulitzer Prize.

After Pearl Harbor, along with millions of Americans, Herb joined the armed services. In the summer of 1945, after Japan surrendered, ending World War II, Herb was anxious to resume his cartooning career, preferably for a newspaper. By yet another "lucky coincidence" he heard from a friend that Eugene Meyer, the immensely wealthy owner-publisher of the *Washington Post* (and father of Katharine Meyer Graham), was looking for a cartoonist. After an exchange of correspondence, they met in New York's Yale Club, Meyer the former Republican Wall Street banker and governor of the Federal Reserve in his business suit, Herblock still in his khaki army uniform.

Portrait Of A Famous Chin

August 4, 1939

PRESIDENT Franklin Roosevelt, although elected to a second term in 1936, faced opposition to his New Deal and his foreign policy from some of the public, members of Congress, and the Supreme Court. Critics disliked the establishment of the US Housing Authority and the 1933 Agricultural Adjustment Act. Isolationists who did not want to fight another European war passed laws promoting neutrality. Laws also limited loans to the European democracies.

Historical Figures

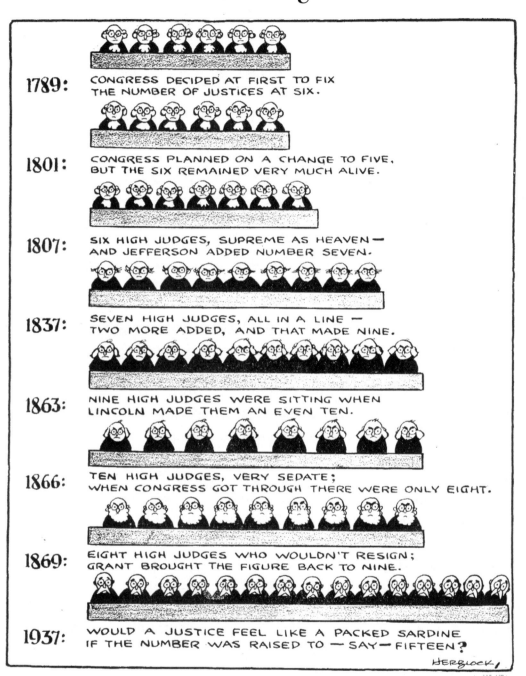

1789: CONGRESS DECIDED AT FIRST TO FIX THE NUMBER OF JUSTICES AT SIX.

1801: CONGRESS PLANNED ON A CHANGE TO FIVE, BUT THE SIX REMAINED VERY MUCH ALIVE.

1807: SIX HIGH JUDGES, SUPREME AS HEAVEN — AND JEFFERSON ADDED NUMBER SEVEN.

1837: SEVEN HIGH JUDGES, ALL IN A LINE — TWO MORE ADDED, AND THAT MADE NINE.

1863: NINE HIGH JUDGES WERE SITTING WHEN LINCOLN MADE THEM AN EVEN TEN.

1866: TEN HIGH JUDGES, VERY SEDATE; WHEN CONGRESS GOT THROUGH THERE WERE ONLY EIGHT.

1869: EIGHT HIGH JUDGES WHO WOULDN'T RESIGN; GRANT BROUGHT THE FIGURE BACK TO NINE.

1937: WOULD A JUSTICE FEEL LIKE A PACKED SARDINE IF THE NUMBER WAS RAISED TO — SAY — FIFTEEN?

HERBLOCK

February 19, 1937

ON February 5, 1937, President Franklin Delano Roosevelt proposed increasing the number of Supreme Court justices from nine to fifteen. For every justice who did not quit the bench after turning seventy, he would be empowered to appoint a new justice, totaling an addition of six. This would have altered a court that had struck down several New Deal creations. The plan failed under opposition from both Democrats and Republicans.

Meyer said he wanted to see more of Herb's prewar cartoons, adding, "and I'll send you a subscription to the paper, so you can see how *you* like *us.*" Meyer made clear that he had no intention of suggesting ideas for cartoons; his policy, he told Herb, was "to get good people and let them do their work"—a policy that was scrupulously followed by his daughter Katharine, her husband, Philip L. Graham, when he was publisher, and ultimately by his grandson Don Graham. The bargain was sealed, the commitment made and kept. Herb then began the long years of distinguished (and syndicated) *Washington Post* work chronicling a succession of dramatic events that continued for nearly six more decades.

When he died of pneumonia at the age of ninety-one on October 7, 2001, the *Post* described him as "a gentle man with a mighty pen who skewered the pompous but never forgot the importance of kindness."

Left unsaid was how death deprived Herblock of chronicling another fateful era that now cries out for his talents. His last cartoon was published on August 26, 2001, just two weeks before the 9/11 terrorist attacks on the United States.

All the events that have flowed from those attacks are tailor-made for Herb's commentary and analysis. Among them: the war in Iraq; the "global war on terror"; the hatred of the United States; the expansion of ever greater governmental secrecy; the acts of torture that have demeaned and diminished the reputation of the United States; the illegal surveillance of American citizens; the warrantless wiretaps; the revelation of new acts of political corruption and political hypocrisy; the reemergence of more religious bigotry spawning new divisions between American citizens; the political attacks accusing opponents of a president's policies of being "soft on terrorism"; the presidential pressure to further expand executive power over the lives of the people.

Herb was a perfectionist, often dissatisfied with his daily product, often wishing he had the opportunity to redo and strengthen his cartoon. But then, in a philosophic mood, he

would take comfort in the knowledge that if his cartoon didn't come out just the way he wished, well, there was always a fresh sheet of paper and a chance to have another shot at it tomorrow.

As he wrote in the closing word of his autobiography, *"Tomorrow!"*

For Herb, the man, there is no more tomorrow. As this volume celebrating decades of timeless work will demonstrate, however, for Herblock, the cartoonist, and others who follow in his footsteps as fighters for freedom and opponents of oppression, there is always a tomorrow.

Haynes Johnson, a long-time colleague of Herblock's on the *Washington Post*, serves on the board of directors of the Herb Block Foundation. He has been an editor, columnist and TV commentator, and is the author of fifteen books, six of them national best-sellers. In 1966 he won the Pulitzer Prize for his reporting of the civil rights crisis in Selma, Alabama.

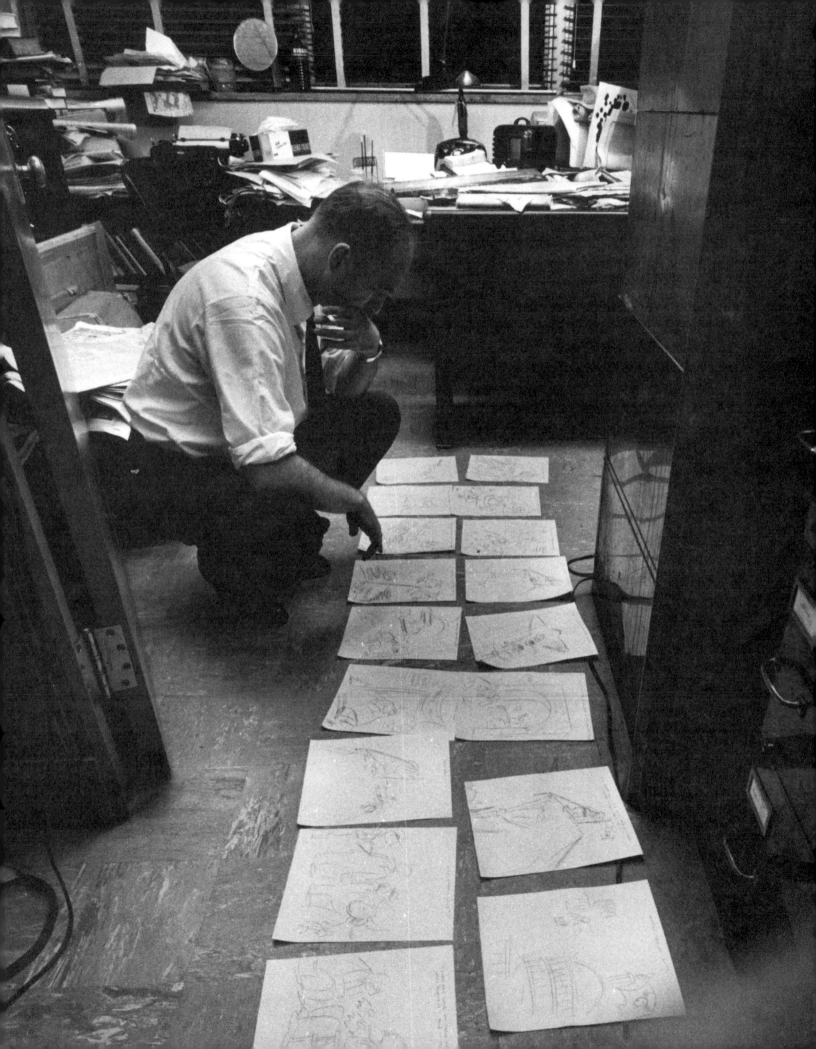

HARRY KATZ

Herblock *Knew*: Herb Block and American Editorial Cartooning

"First be right; then, be effective; then, be a good artist."
— HERBLOCK

Herblock had no peer in the history of American editorial cartooning. His unique blend of humor, art, knowledge and intelligence, journalistic insight, humanism and compassion, and fierce independent spirit set him apart. He campaigned for causes he cared for rather than tossing off cartoons in response to daily headlines. His career dwarfed those of his contemporaries and his predecessors. His awards, accolades, and influence were unprecedented.

Thomas Nast approached such heights but his ethnic and religious prejudices, relatively short career, and lack of a professional following dim his otherwise brilliant star. Other candidates for the laurel of best American political cartoonist, Jay "Ding" Darling, Art Young, Bill Mauldin, Pat Oliphant, Rollin Kirby, for example, all brought, or bring, remarkable skills to bear in their work, yet Herblock remains in a category of his own. He excelled for over seventy years and on numerous occasions stood up for his beliefs in the glare of international scrutiny against the wishes of his own employers and the opinions of most of his professional colleagues, risking his reputation and his livelihood.

He understood early on that he was part of a centuries-long tradition of journalism, art, history, and social progress. Furthermore, perhaps he recognized that the test of greatness for any cartoonist lies in the body of his work rather than the scattered influence of single cartoons or caricatures. Certainly, no other American cartoonist ever confronted so many controversial issues and episodes over so many years as Herblock did during his magical run.

The canon of political courage and conviction in graphic art opens with such European masters as William Hogarth (1697–1764), who introduced the art of social caricature; Francisco Goya (1746–1828), who laid bare the political and religious oppressiveness of royal Spain and the horrors of warfare in the eighteenth

century; James Gillray (1757–1815), a brilliant, mercenary cartoonist whose acid-dipped etchings led a golden age of British satirical prints; and Honoré Daumier (1808–1879), the nineteenth-century Frenchman who drew for the working classes, went to prison defending his right to publish freely, and set the standard of political art for generations to come.

America's first professional editorial cartoonists mostly came from Europe, although native son Benjamin Franklin is credited with publishing the country's first political cartoon in 1754. Scotsman William Charles, German-born Nast, and Austrian immigrant Joseph Keppler were among those who dominated the profession in the United States during the nineteenth century.

Aware of and informed by them, Herb Block nonetheless came from a very different tradition. He was born and brewed in the Midwest. His humanism and compassion came from the heart and from the heartland. His parents imbued him with a heartfelt impulse to "think about the other guy," without considering race, creed, religion, or gender. Block's father, a moderate, independent-minded

"Shall We Say Grace?"

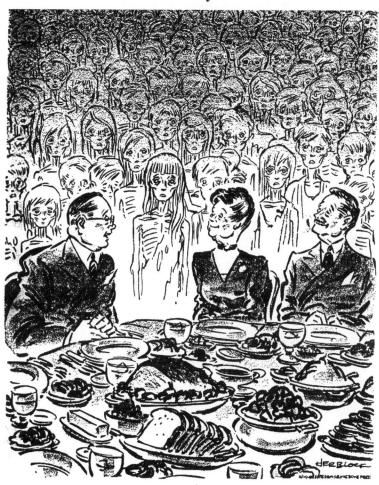

March 23, 1946

IN haunting counterpoint to Norman Rockwell's plump, glowing Thanksgiving feast depicted in the 1943 poster *Freedom From Want*, Herblock juxtaposes his bountiful repast from 1946 against a backdrop of starved, skeletal figures representing Europe's post-war displaced children. He reminds Americans of their moral obligation in a time of victory and plenty to rebuild Europe and care for the war's sick, hungry and homeless.

Republican, had been a newspaper reporter and occasional cartoonist early in his career, while Herb's older brother Bill worked as a reporter for the *Chicago Tribune.* Growing up in Chicago, America's "Second City," pulsing urban center of the Midwest, Herblock was steeped in politics and current events. Encouraged by his dad, as a youth and teenager he drew prodigiously and prolifically, publishing cartoons in his high school paper and local newspapers. By age nineteen he had embarked on a professional career as an editorial cartoonist for a major American city daily newspaper, the *Chicago Daily News.*

Warm, good humor is the first trait we associate with Herblock. Popular 1930s comedian Will Rogers once said, "There's no trick to being a humorist when you have the whole government working for you." Herblock was the Will Rogers of American cartooning, blending homespun humor and incisive wit into bold, crafty cartoons in the sincere belief that an informed, engaged electorate is the truest safeguard for an energized democracy. Like Rogers, Herblock delivered hard truths with a soft, deft touch, and timeless observations in a folksy, familiar style. However, Robert Osborn, one of America's foremost political illustrators during the 1950s, wrote, "I think

Look Out For Average Man!

(A Cartoon by Herblock, and an Editorial by Bruce Catton)

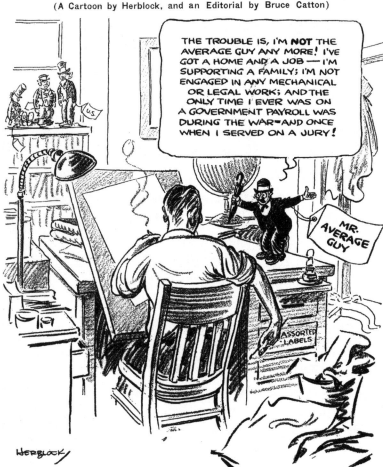

THE TROUBLE IS, I'M **NOT** THE AVERAGE GUY ANY MORE! I'VE GOT A HOME AND A JOB — I'M SUPPORTING A FAMILY; I'M NOT ENGAGED IN ANY MECHANICAL OR LEGAL WORK; AND THE ONLY TIME I EVER WAS ON A GOVERNMENT PAYROLL WAS DURING THE WAR—AND ONCE WHEN I SERVED ON A JURY!

MR. AVERAGE GUY

ASSORTED LABELS

August 17, 1935

H ERBLOCK produced this surprisingly autobiographical self-caricature of the cartoonist listening to his muse for a mid-thirties NEA illustration accompanying an editorial by friend and colleague Bruce Catton, who later gained fame as a Civil War historian.

In A State Where You Can't Teach Evolution

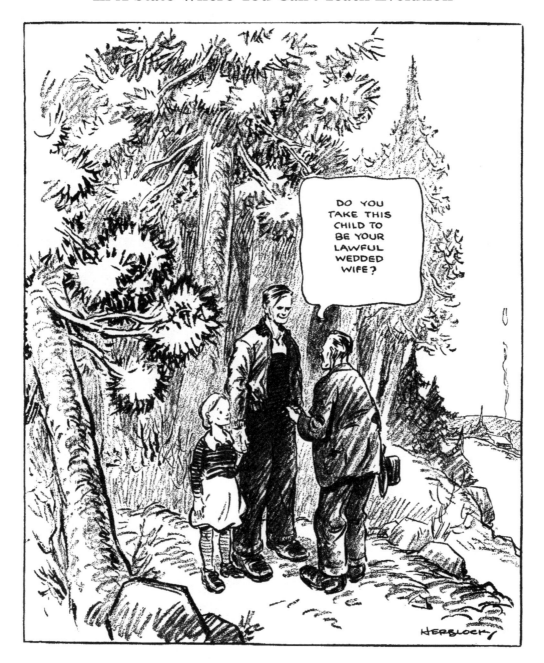

February 3, 1937

THE 1925 Scopes trial drew national attention to the conflict between those who believed in biological evolution and those who championed creationism—in which the biblical God created the earth and its inhabitants in seven days. Herblock made the connection between state laws that required teaching biology based on religion rather than science and laws in those states that in effect legalized pedophilia by allowing adults to marry children.

what distinguishes Herblock is that in a culture which is sugar-coating everything and which is scared to even mutter the unvarnished truth—Herblock comes out everyday with the unvarnished truth." Five decades later, upon the centennial of his birth, his cartoons and commentary radiate his lifelong quest for right not righteousness, sense not senselessness, action not apathy, and justice above all.

Artistically speaking, Herblock remains one of America's most underappreciated cartoonists. Remembered for his corpulent congressmen and fat-cat capitalists, he was in truth a highly accomplished draftsman who found a stark, simple, but effective style early on and simply *chose* to display his considerable artistic skill only rarely when it served his editorial purpose. At the *Chicago Daily News* in 1929, Herblock came under the influence of stalwart members of the "Midwestern School of Editorial Cartooning" such as Vaughn Shoemaker, his senior at the *News*, and John T. McCutcheon, who toiled for the *Chicago Tribune.* The Midwestern School, as historian Lucy Caswell describes it, was characterized by a strong sense of place, a loose and energetic line, a pervasive positivity and playfulness, and a visual-verbal vocabulary defined by a liberal use of symbols and labels. For example, Herblock frequently turned to "John Q. Public," Uncle Sam, "the World," and the GOP elephant and the

Hide and Seek

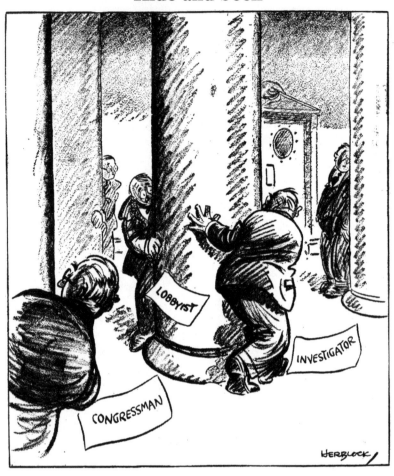

July 15, 1935

HERBLOCK tracked the Capitol Hill cat-and-mouse games played by congressional committees and lobbyists from his earliest years.

Democratic donkey to carry his points. This was common at the time for, as Professor Caswell notes, the *Des Moines Register*'s celebrated Ding Darling, an early Herblock hero, created "Ordinary Man," a familiar figure who by turns "was taxpayer, voter, consumer, and, sometimes, he was bamboozled." In addition, midwestern cartoonists usually demonstrated a strong sense of right and wrong and profound moral outrage when those senses were betrayed. For the first few years, in Chicago and Cleveland, as Herblock found his professional footing, his cartoons predominantly reflect the influence of the Midwestern School.

In fact, at the *Chicago News* Herblock was a young man finding his own way and his own style. The city was beset by crime and depression, but his cartoons make the best of it, capturing the era's dark clouds and some silver linings. During the Hoover administration he supported the Republicans and boosted their policies through the stock market crash and into the Great Depression. He praised Hoover's attempts to jump-start big business and bemoaned the fate of those undone by the lean economic times. He was an eternal optimist, however, and never lost faith in the power of government to bring about a turnaround.

Life changed profoundly for Herblock when he was hired in early 1933 by the Newspaper Enterprise Association (NEA) syndicate, located in Cleveland, Ohio. His new position coincided with the election of Democrat Franklin Delano Roosevelt to the White House and the concurrent

Presidential Crossings

January 14, 1932

AT the outset of the Great Depression, working in Chicago and still in his early twenties, Herblock was a Herbert Hoover booster, portraying the president as generally effective and well-meaning.

deepening of the nation's economic and social woes. Crime and unemployment increased exponentially, farms and houses were foreclosed, banks and businesses closed, and countless American families suffered countrywide. Roosevelt took charge with a hands-on attitude that Herblock mightily admired. He began to embrace leaders who led by example, who worked for those who were not working and provided for those who had nothing, who constantly thought about "the other guy." In cartoon after cartoon, Herblock began to promote FDR's New Deal activism, seeing within it an opportunity to push and prod Americans and America out from the shade of depression to the sunny side of the street.

In style and technique Herblock's work, too, underwent fundamental change. A more powerful, much broader graphite style replaced the loose scratchy lines of the Midwestern School. Influenced by the potent lithographs of Daumier and the strong contemporary cartoons they engendered by such established and more liberal, even radical, colleagues as Robert Minor, Boardman Robinson, and Daniel Fitzpatrick, Herblock matched the ominous world outlook to his maturing graphic gravitas. His figures became more modeled and expressive, his cartoons more moving and affecting. He became more sophisticated in his choice of topics, addressing the fascist threat in Europe, global hunger, active or impending wars, and international diplomacy. Like America, beset by adversity from without and within, Herblock grew up fast.

Breaking Up The Jam Along The Potomac

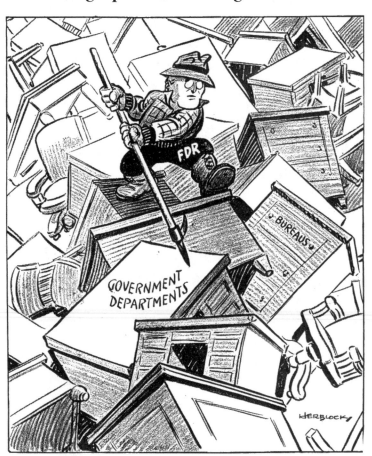

January 14, 1937

HERBLOCK portrays Franklin D. Roosevelt at the start of his second term as a logger with a pike, working heroically to break apart the logjam of government bureaus and departments created by his administration's New Deal policies.

The most dramatic change in Herblock's art, the truest insight into his remarkable professional personality, can be seen in his cartoons addressing McCarthyism and civil rights. Typically he used humor to engage the viewer and carry his message. However, when he felt strongly about some particular issue, event, or public figure, the power of his drawing came to the fore. In "Room with a View," from 1949, his painterly skills open our eyes to the tragic paradox of poverty festering within the shadows of the United States Capitol. The gritty, realistic 1954 portrait of Joe McCarthy entitled "I Have Here in My Hand—" transcends caricature, reducing the politician to a shabby, shady huckster. His rendering of a horrific lynching near Poplarville, Mississippi, in 1959 betrays an outraged Herblock, eschewing his usual cartoon style for a haunting, expressive ink technique, depicting the scene with all the pain and passion he could muster. Time after time, in the aftermath of the deadly 1989 Tiananmen Square protests in China, for example, he drew with a skill and will rarely evident in his more humorous panels.

If Herblock summoned his artistic resources intermittently to empower his ideas, his independent nature seemed always at hand. His boss at the NEA, Fred Ferguson, for one, thought Herblock reported to him. In the run-up to World War II the two

Solution To Nothing

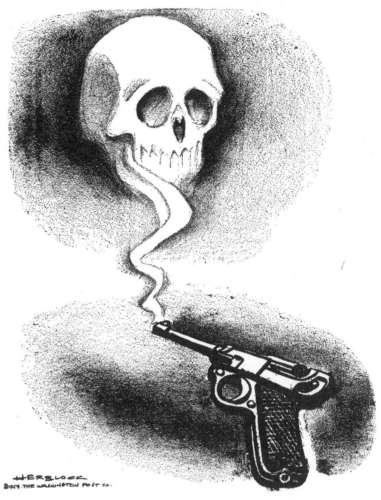

March 2, 1954

HERBLOCK'S long-familiar crusade against gun violence began in crime-ridden Chicago during the 1930s and accelerated sharply after the assassination of President John F. Kennedy in 1963.

often clashed over U.S. intervention in the European conflict. An internationalist, Herblock recognized that without American intervention Adolf Hitler's Nazi brand would soon mark all of western Europe. As early as 1933, Hitler and his junior Axis partner Benito Mussolini appeared as menacing figures in Herblock cartoons. Reflecting the country's prevailing isolationist leanings at the time, Ferguson and his cronies took exception to Herblock's efforts. By 1941, as the cartoonist himself put it, "Our differences were hard to reconcile." In spring 1942, the timing exquisite as he waited to be called on the carpet, perhaps fired for his sins by Ferguson, Herblock received his first Pulitzer Prize for editorial cartooning. After the Japanese attack on Pearl Harbor, the isolationists were silent. Ferguson, chastened, retained Herblock and eased off his editorial badgering. Herblock, through his own talent, obstinacy, and conviction, was largely off the leash. The most independent newspaper cartoonist in American history had embarked on his personal path to free expression.

Between 1943 and 1945 Herblock served in the army, putting his graphic talents to work creating cartoons for American troops at home and abroad, his editorial work set aside until the Armistice. Herblock first served as a

"People's Republic"

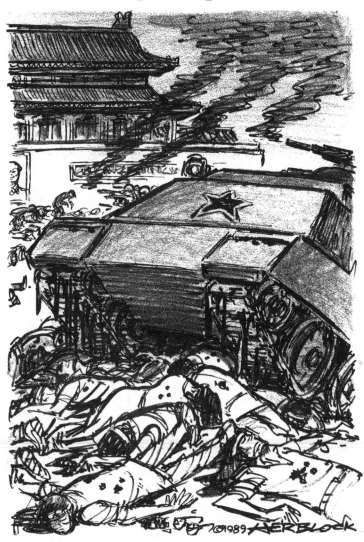

June 6, 1989

ON June 3 and 4, 1989, Chinese army troops and tanks rolled into the Tiananmen Square area in Beijing to crush student-led pro-democracy protests. Residents of other cities in China and nations worldwide protested the bloody crackdown. Casualties were estimated at 5,000. Herblock reprinted this cartoon ten years later as a reminder of the Chinese rulers with whom Americans were dealing.

private drawing cartoons for a camp newspaper at the army Air Force Tactical Center near Orlando, Florida. He then transferred to New York City where he wrote articles and drew cartoons for an in-house army "clipsheet." He mustered out as a sergeant in late 1945.

Following the peace he went back to work with a vengeance, installed in the nation's capital at the revitalized *Washington Post,* owned by Eugene Meyer and published by Phil Graham. There he started again with a fresh perspective far from the midwestern vantage point where he had begun. Working near Capitol Hill, amidst federal workers and public officials, and D.C. residents who paid taxes but could not vote, Herblock settled in confidently and began to forge an industry legend.

In Washington, he became even more independent, due in large part to a miscalculation by *Post* publisher Graham during the 1952 presidential election campaign pitting Republican candidate Dwight Eisenhower against Democratic opponent Adlai Stevenson. Herblock's pro-Stevenson cartoons angered Graham, who backed Eisenhower. Entering the final weeks of the campaign, the publisher asked his cartoonist to stop submitting cartoons opposing Ike's candidacy. Herblock, who was also nationally syndicated at the time, agreed to drop his offending work from the *Post.* As a result, several subsequent syndicated Herblock drawings portray-

"Naughty Naughty"

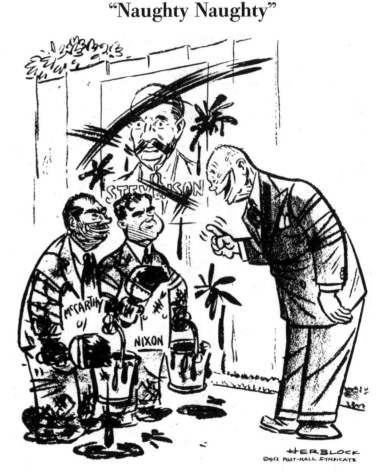

October 29, 1952

HERBLOCK'S depiction of President Dwight Eisenhower—Ike—as a timid teacher meekly disciplining Republican bad boys Richard Nixon and Joseph McCarthy was one of several pulled from the *Post* by the cartoonist at the request of his publisher Phil Graham. Herblock agreed to withdraw his drawings from the *Post,* but readers complained and dropped their subscriptions. Herblock was soon reinstated.

"All Are Gone, The Old Familiar Fasces"

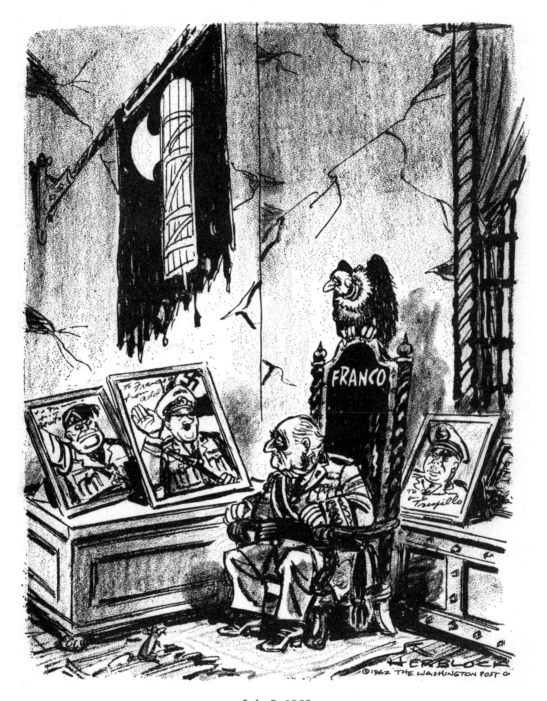

July 5, 1962

BY 1962, Adolf Hitler, Benito Mussolini and many other military dictators of the first part of the twentieth century had died or been driven from power. Still grasping the reins was their ally, General Francisco Franco, whose Fascist government ruled Spain. Herblock modified a Charles Lamb line, replacing "faces" with "fasces," the word for an ax tied into a bundle of rods that was the ancient Roman symbol for authority and later the source for the term "fascism."

Heating Up the Cold War, 1946–1965

By 1946 Herblock had become a daily fixture in the *Washington Post,* attracting great attention and growing numbers of both admirers and critics. An America that had emerged from the global devastation of World War II as the world's leading power, presiding hopefully over a new, more peaceful era, quickly found itself facing a new, more frightening period—the Cold War. Hitler had passed from the scene, but the threat posed by other dictators from the Soviet Union's Joseph Stalin to China's Mao Tse-tung and North Vietnam's Ho Chi Minh raised concern about a new, even more terrible kind of war. With the dropping of the atomic bomb over Hiroshima in August 1945, the world faced the possibility of a nuclear holocaust. It was an age of anxiety, the age of the Iron Curtain and the Berlin Wall in which East and West eyed each other warily with missiles ready to launch; when Communist China rivaled the Soviet Union as the world's greatest military force and became a source of new threats to U.S. and Western alliances.

It was also a time of heated debates within the United States over communist infiltration, spies, and betrayal, polemical questions about "who lost

"Pardon Me, Mister—Do You Know What Time It Is?"

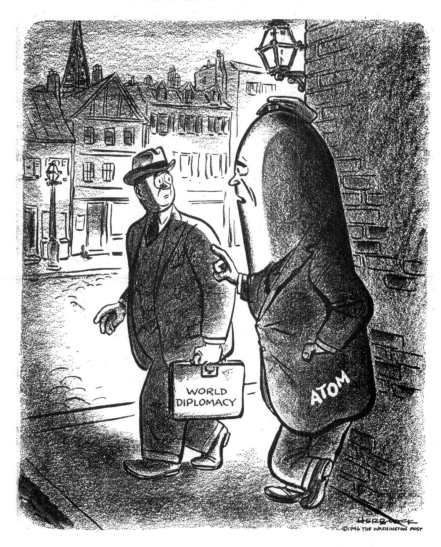

China" and how the United States appeared to be weakened by traitors within. These Cold War tensions mounted until they exploded in the hot war of Korea in June 1950. The new war left presidents and policy makers from Truman, Eisenhower, and Kennedy and their key aides, including the secretaries of state John Foster Dulles and George C. Marshall, to grapple with increasing tensions and new world opponents such as Soviet leader Nikita Khrushchev. Of all Herblock's portraits in this period, perhaps most memorable are those in which he draws the fearsome figure "Mr. Atom." Another powerful portrait is the cartoon in which he superimposes the shadow of a nuclear weapon against the United Nations headquarters building in New York, home to the organization formed after World War II to bring peace to a suffering world.

Mr. Atom

Herblock said, "Among less personal characterizations, the one of Mr. Atom—based on the bomb of the same name—is a figure that just grew. He wasn't planned as a continuing character, but after his first appearance he kept muscling into the pictures as a warning that he wasn't going to be permanently on our side alone and that if he weren't controlled he could cut loose on the whole world."

August 27, 1946

I N the summer of 1946, two atom bombs were detonated during an American nuclear test conducted in the Marshall Islands. Observed by a large international press contingent, the event re-emphasized the United States's position as the world's leading nuclear superpower following World War II and provided evidence regarding toxic radiation. Herblock recognized the perilous path taken by those advocating military dominance through nuclear weapons.

"Don't Mind Me—Just Go Right On Talking"

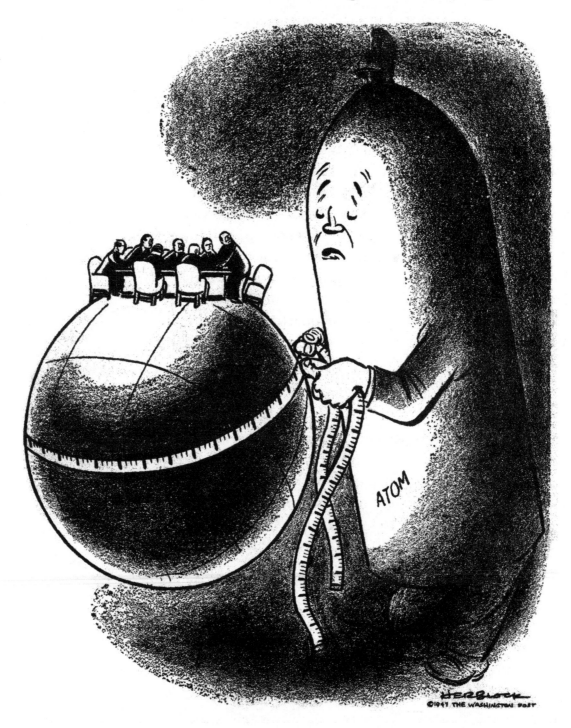

February 18, 1947

AMERICA'S monopoly on the atom bomb lasted just four short years. In August 1949 Russian scientists exploded their own version, spreading fear and anxiety throughout Europe and the United States and causing a dramatic shift in the global balance of military power.

September 24, 1949

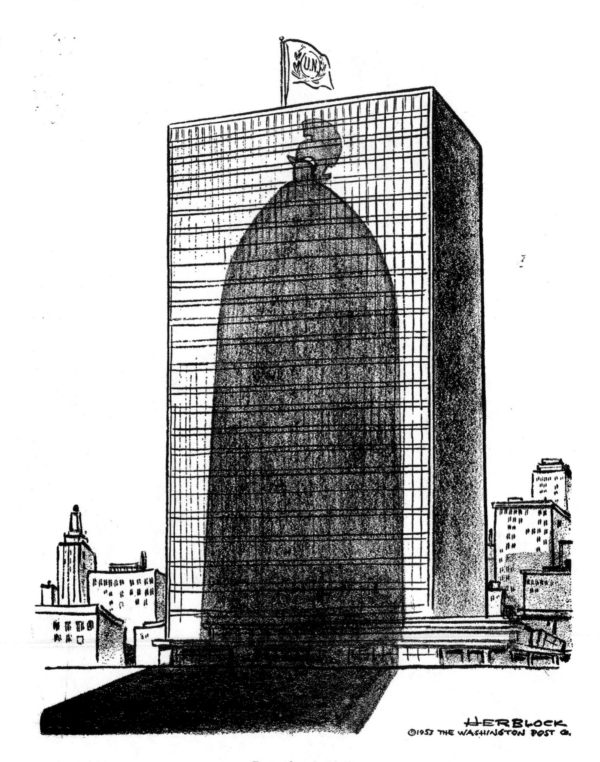

December 8, 1953

ON December 8, 1953, United States President Dwight D. Eisenhower spoke before the United Nations Assembly, eloquently proposing "Atoms For Peace," a program which would extend American aid to countries contributing nuclear power for peaceful purposes. He declared that "it is not enough to take this weapon out of the hands of the soldiers. It must be put into the hands of those who will know how to strip its military casing and adapt it to the arts of peace."

"Fire!"

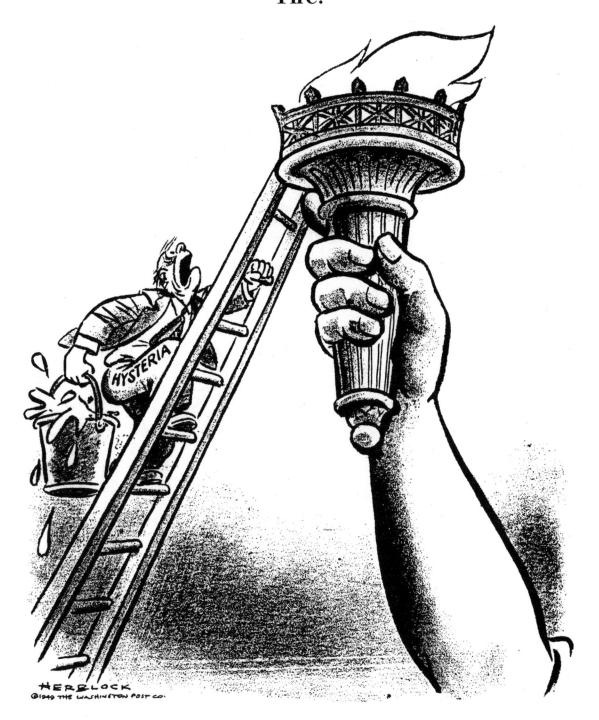

June 17, 1949

AFTER World War II, the Soviet Union expanded its control to most of Eastern Europe, and it appeared that China would soon fall to the Communists. Herblock drew this cartoon in response to the postwar "Red Scare" hysteria sweeping the nation, as anti-communist crusaders led by the House Un-American Activities Committee threatened civil liberties in their efforts to preserve democracy.

The Beautiful Postwar World

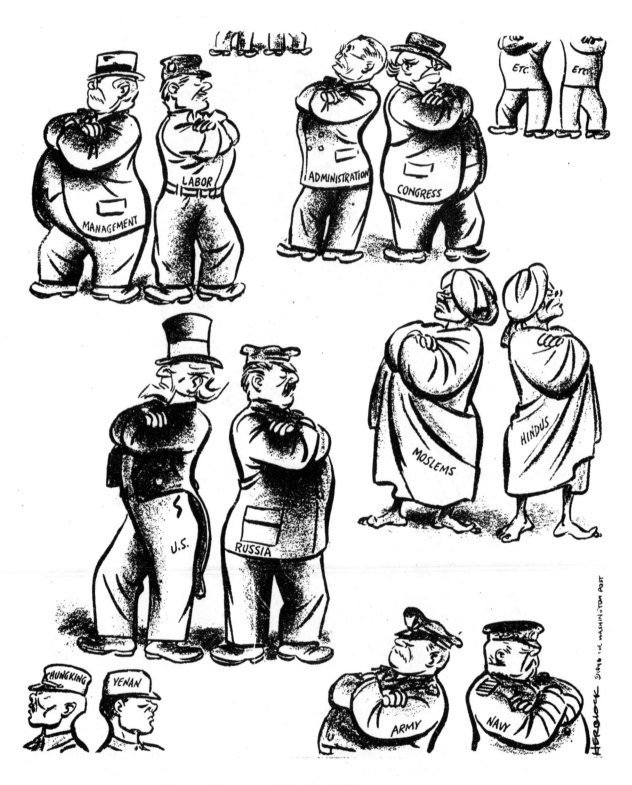

May 20, 1946

Wings Over Berlin

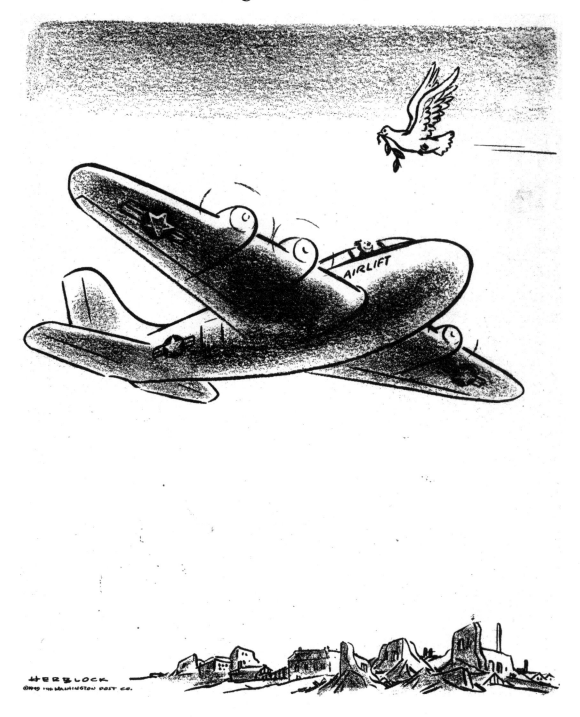

April 27, 1949

IN June, 1948, American, French and British aircraft under U.S. direction carried humanitarian aid to the Allied sectors of Berlin, Germany, in defiance of a Soviet blockade. By April 1949, flights were arriving every few minutes. By that summer, when the blockade was finally lifted, the Berlin airlift had transported more than two million tons of supplies.

"You Know, That Cold War Wasn't So Bad"

September 23, 1950

THE Cold War became a shooting war in June 1950 when Northern Korean troops, supported by communist China, invaded South Korea. By mid-July, the United States had committed troops to a "police action" enforcing the United Nation Security Council demand that the North Korean army withdraw from its neighbor's territory. More than 36,000 American soldiers lost their lives in the Korean War, ended by cease-fire in June 1953.

"You Mean Some Can And Don't Do It?"

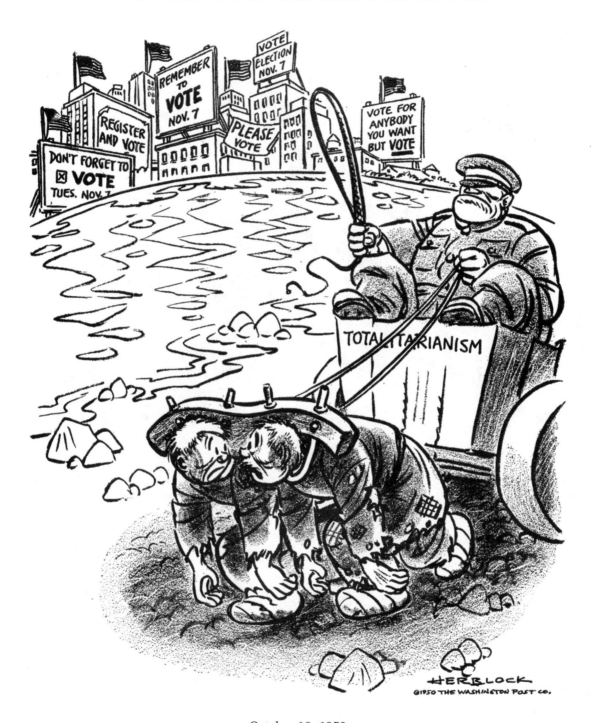

October 18, 1950

IN his reminder to vote on November 7, 1950, Herb Block conveyed his own global perspective on the priceless value of voting rights. Two ragged drudges, who are portrayed as physically oppressed by the yoke of totalitarianism, express incredulity that U.S. citizens with the precious right to vote sometimes choose not to exercise it.

"White Is Black. Black Is White. Night Is Day—"

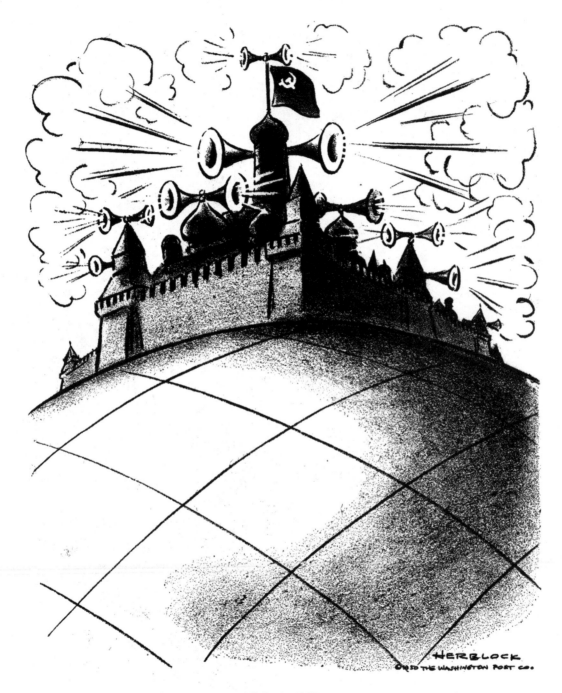

July 6, 1950

"HOW often we wish we could respond to the call of the great outdoors and get away from it all," wrote Herblock. "In Sovietland the wish can be gratified." Herblock referred ironically to the Soviet government's likelihood to send dissident citizens to work in Siberia and experience the "rugged outdoor life....The dream that makes every man-blooded Red tingle all over as the cold sweat stands out on his brow."

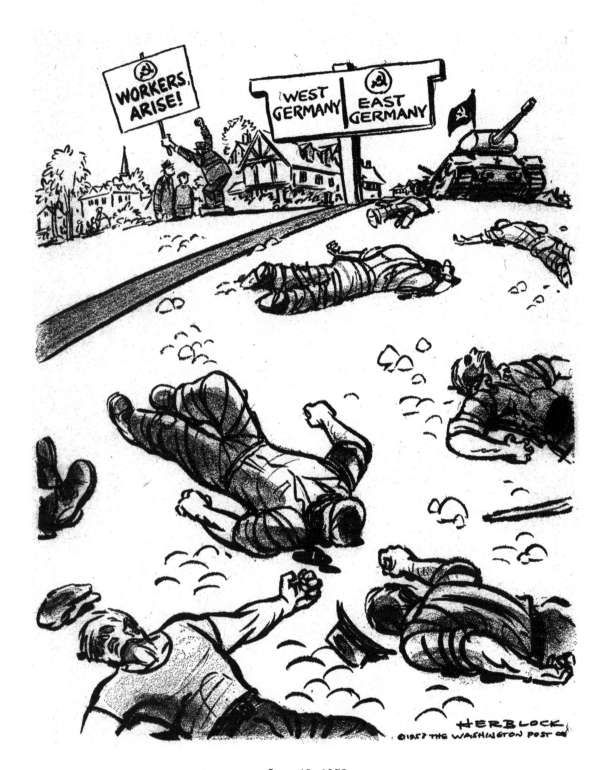

June 19, 1953

IN the first documented popular uprising against Soviet rule in post-war Europe, more than one hundred protesters were killed and at least an equal number later executed, when Berlin construction workers protested against pay cuts tied to stricter quotas. Occurring just three months after Soviet Premier Joseph Stalin's death, East German and Soviet tanks ruthlessly quelled the riots incited by the demonstrators.

"You Were Always A Great Friend Of Mine, Joseph"

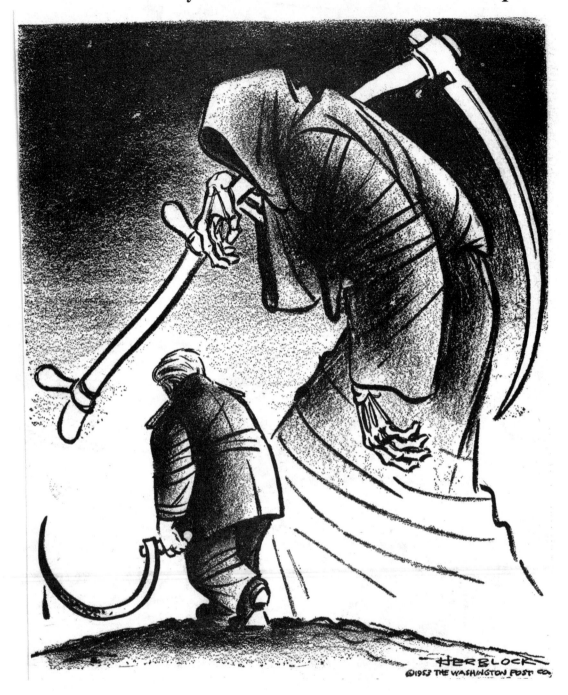

March 5, 1953

WHEN he died in March 1953, Soviet Premier Joseph Stalin had been responsible for the deaths of an estimated thirty million Russians through war, starvation, torture, disease and elimination. Herblock won his second Pulitzer Prize largely on the strength of this powerful indictment of the Communist strongman. Stalin's last walk with Death is a fitting tribute to one of history's most infamous figures.

1-Point Program

July 19, 1955

HERBLOCK cuts through all of the rhetoric surrounding multi-point programs for nuclear arms negotiations, insisting that the single point worth considering is the safety and security of the world's future: its children.

"Testing—Aggressor! Imperialist! Assassin! Testing—"

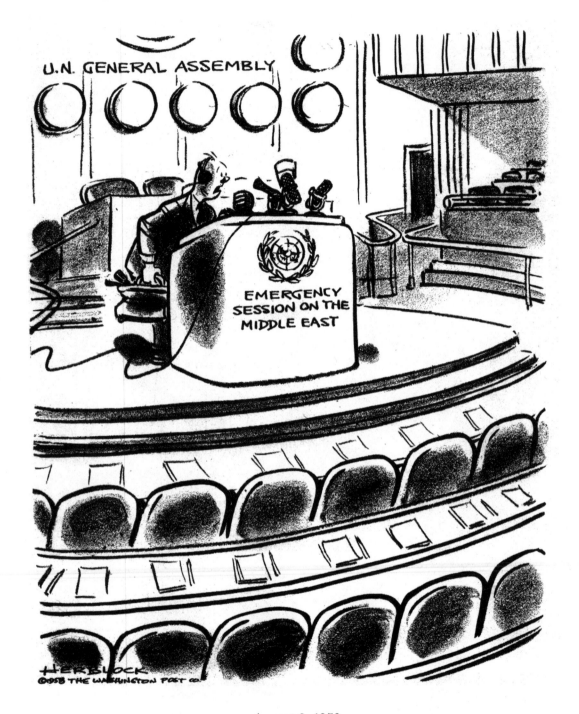

August 8, 1958

HERBLOCK satirically suggests that by 1958, a decade into the Cold War pitting the U.S. against the Soviet Union in a conflict of social ideologies and economic theories, Americans and their capitalist allies in the United Nations were often subjected to epithets accusing them of colonial aggression and murderous political attacks.

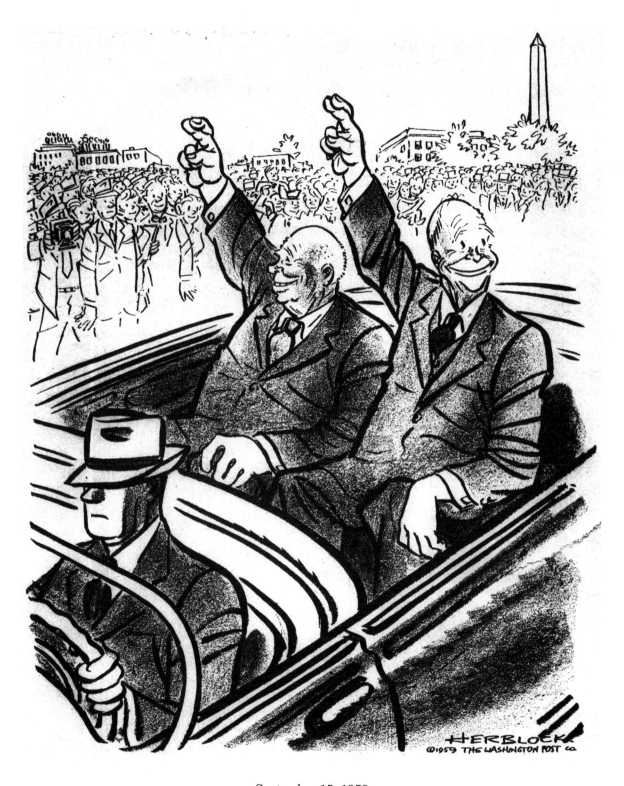

September 15, 1959

IN September 1959 Soviet Premier Nikita Khruschev visited the United States for ten days and met with President Dwight D. Eisenhower in an effort, as he put it, to promote "peaceful co-existence." Herblock was skeptical!

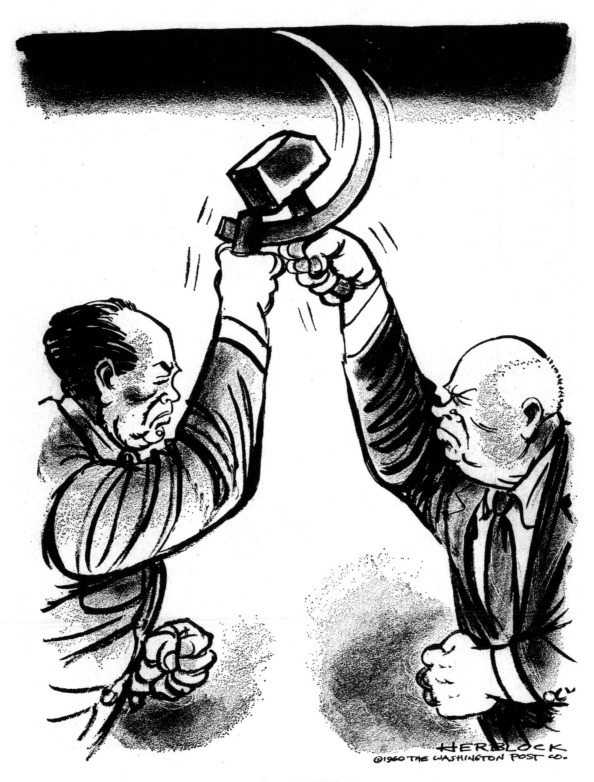

June 24, 1960

HERBLOCK employed the Soviet symbol of the hammer and sickle to depict a meeting of the minds between Premier Khrushchev and Chinese Chairman Mao Tse-tung, suggesting Russian domination of the Communist world at the time.

"You're New Here, Aren't You?"

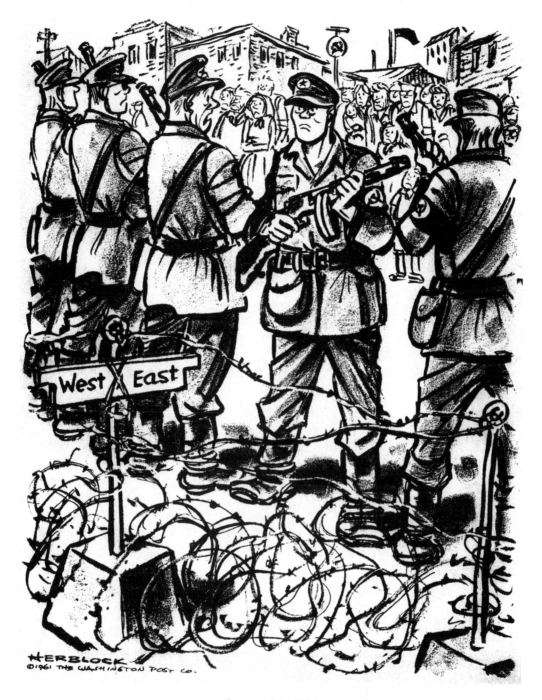

August 30, 1961

CONSTRUCTION began on a plan to separate East from West Berlin on early Sunday, August 13, 1961, and by the next day East Berliners were barred from entering Western sectors. The initial barricades soon proved ineffective and a formidable wall was built. This barrier was created to keep the city's residents in, not to prevent unwelcome visitors. In 1989, with the fall of the Soviet Union, the Berlin Wall was dismantled.

"Let's Get A Lock for This Thing"

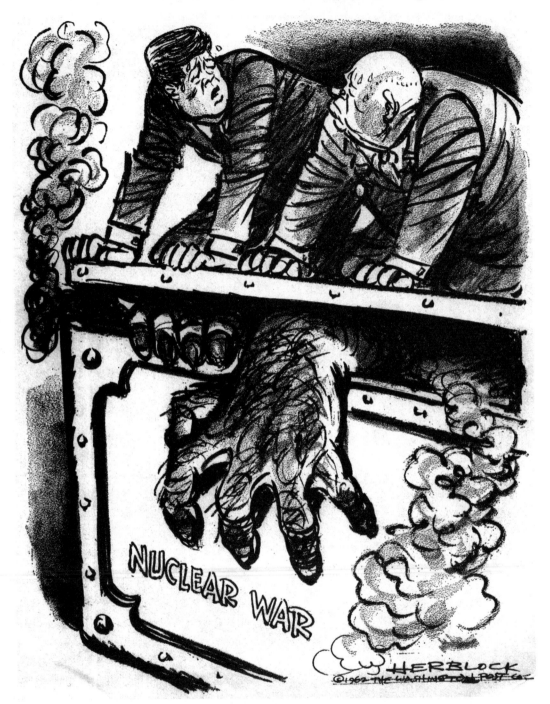

November 1, 1962

IN the aftermath of the Cuban Missile Crisis in October 1962, both Soviet Premier Nikita Khruschev and U.S. President John F. Kennedy recognized that they had brought their nations to the brink of nuclear annihilation. On August 5, 1963, the two leaders signed a landmark Nuclear Test Ban Treaty, for the first time setting limits on the escalating global arms race.

Mushrooming Cloud

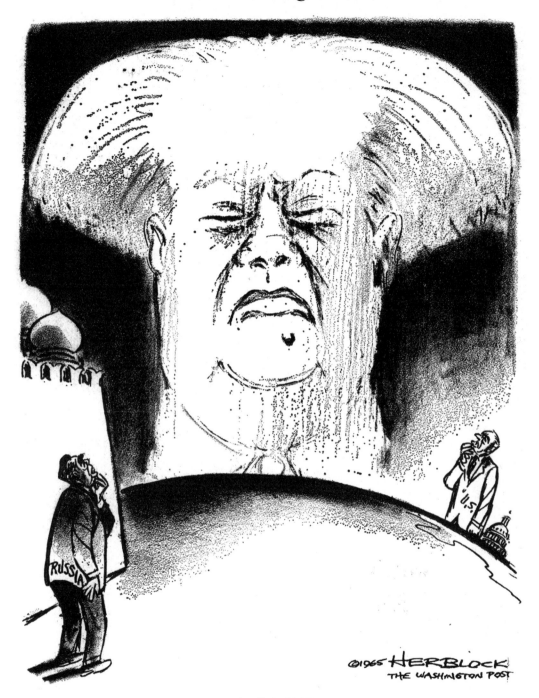

April 1, 1965

COMMUNIST China exploded its first atomic bomb in October 1964, and the U.S. State Department warned in February 1965 that the Chinese were preparing another nuclear test. Although the Soviet Union insisted that the Chinese tests did not pose a threat, Herblock's menacing, blossoming caricature of leader Mao Tse-tung suggests that China's emergence as an unbridled nuclear power was a world-wide concern.

McCarthy and McCarthyism

Herblock and Joe McCarthy were made for each other: the great cartoonist and opponent of government tyranny versus the most destructive demagogue in American history. "McCarthyism," a disgraceful era in which reputations were destroyed by Senator McCarthy's congressional witch hunts and use of guilt-by-association tactics, lasted for five years, sowing fear and suspicion not only throughout the nation's capital but across the country. The McCarthy era finally ended when the Senate censured him in 1954, concluding a terrifying political reign but one whose tactics of attacking political enemies with false charges and sowing fears of lack of patriotism have continued for decades. Herblock gave the era its lasting name on March 29, 1950. That morning, readers saw his depiction (see p. 22) of a reluctant GOP elephant being pushed toward a pillar of oozing tar buckets. The largest bucket, at the very top, was labeled "McCarthyism." The tag line over the drawing had the elephant saying: "You mean I'm supposed to stand on that?"

The tar brush wielded by McCarthy became a familiar symbol in Herblock's drawings of this era. So did his use of the House Un-American Activities Committee hearings relying on false testimony to smear witnesses and expose supposed subversives, some of whom were guilty of nothing more than reading books and raising questions about unfair charges. One of Herblock's cartoons from this period is especially powerful (see p. 115). It shows a man labeled "hysteria" racing up a ladder, carrying a bucket of water, to put out the fire glowing from the Statue of Liberty. If one knows nothing of the McCarthy period, these drawings help explain why it was so dangerous and combustible—and why the lesson of demagogues employing fears and smears remains timely decades later.

New Broom

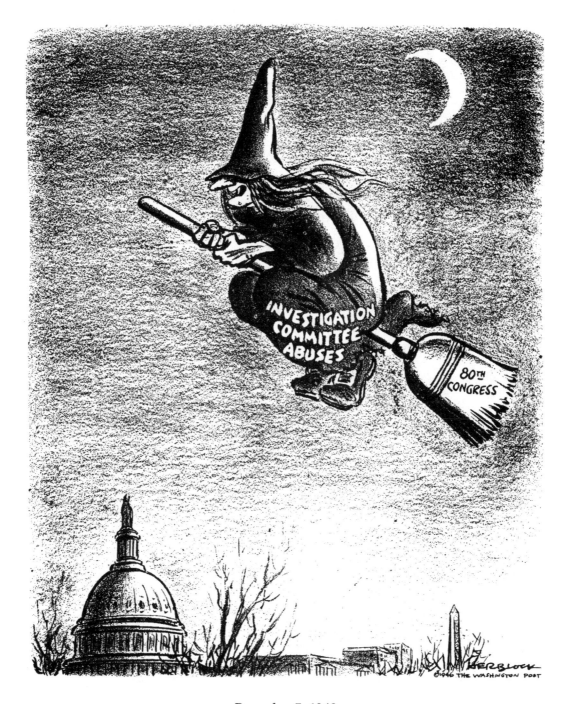

December 7, 1946

CREATED in 1938, the House Un-American Activities Committee (HUAC) gained widespread support after 1945 under the leadership of New Jersey's Republican Senator Parnell Thomas. Thomas and his colleagues sought evidence through hearings and investigations in an effort to sweep out public officials and private citizens that they thought were displaying signs of disloyalty, subversive activities or Communist affiliations.

"You're With The State Department, I Presume"

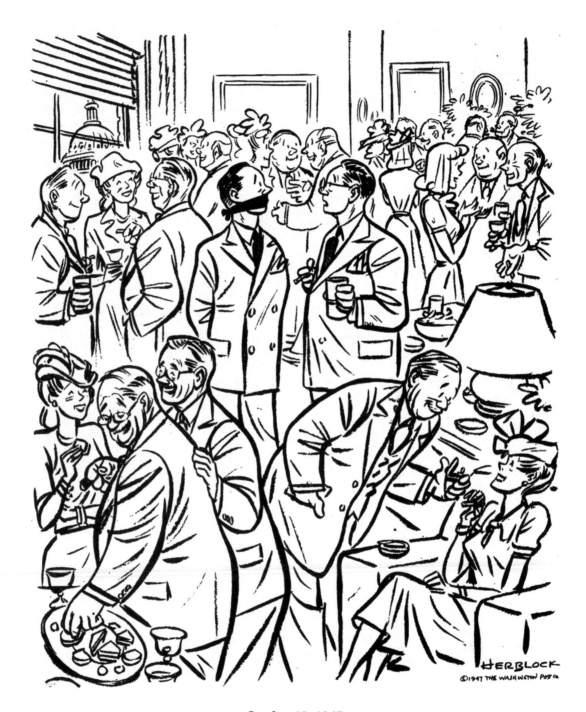

October 13, 1947

THE specter of Soviet spies in the U.S. state department bedeviled American legislators immediately after World War II, when a new Red Scare worried the nation. Ever sensitive to the Washington social scene, Herblock imagined the impact on cocktail parties of ongoing investigations by HUAC.

"Is Joe Stalin Running In All These Elections?"

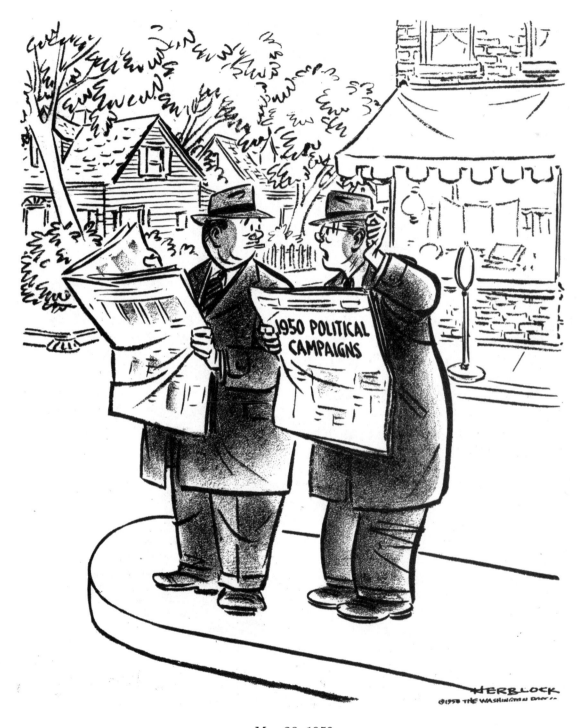

May 28, 1950

"IT might be a good idea if all our speakers agreed that what Stalin wants is whatever he can get, and that nothing would make him happier than to see us so fearfully concerned about his pleasure or displeasure that we have made complete fools of ourselves," wrote Herblock

"Stop Ganging Up On Me!"

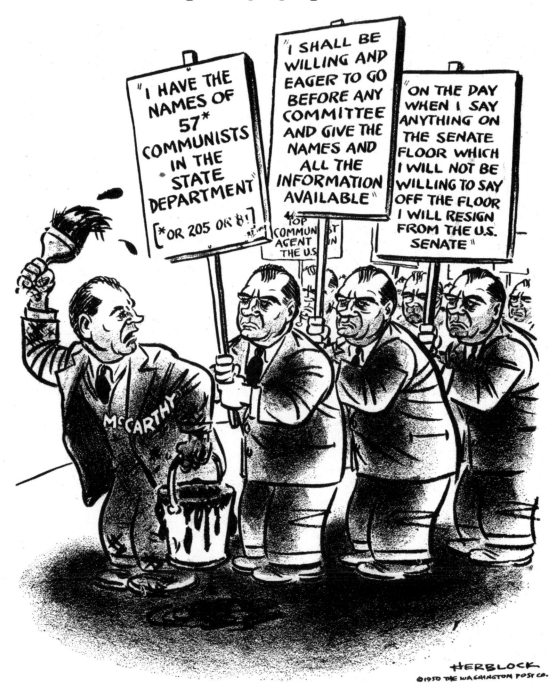

April 22, 1950

HERBLOCK began his cartoon campaign against Senator Joseph McCarthy following a speech in February 1950, when the lawmaker held up a sheet of paper claiming it was a list bearing the names of 205 State Department staffers known to be members of the American Communist Party. By April, Herblock and other journalists had uncovered other unsavory aspects of the senator's career in an effort to discredit his crusade.

"We Now Have New And Important Evidence"

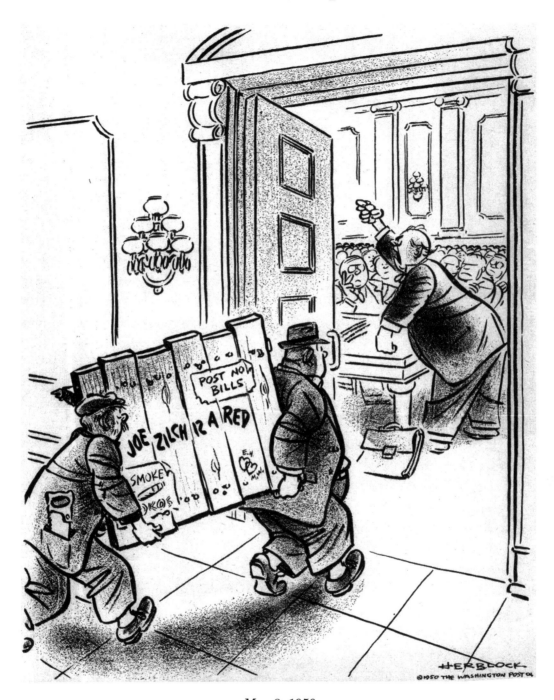

May 8, 1950

THE Senate appointed a special committee under Millard E. Tydings to investigate McCarthy's "evidence." McCarthy managed to turn the hearings into a circus, each new charge obscuring the fact that earlier accusations weren't backed up. Despite a final report discrediting McCarthy's tactics and evidence, he emerged with more general support than ever. And "anti-subversive" hearings by other congressional committees continued treating rumors and unsupported charges as "evidence."

"Say, What Ever Happened To 'Freedom-From-Fear'?"

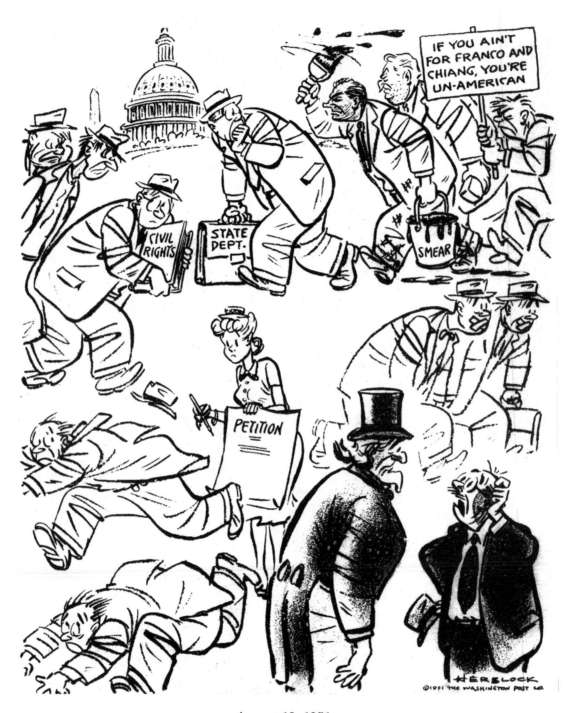

August 13, 1951

AS Senator Joseph McCarthy's campaign against State Department and Justice Department officials continued, President Harry Truman spoke against "scaremongers and hatemongers" who "are trying to create fear and suspicion among us by the use of slander, unproved accusations, and just plain lies."

Nothing Exceeds Like Excess

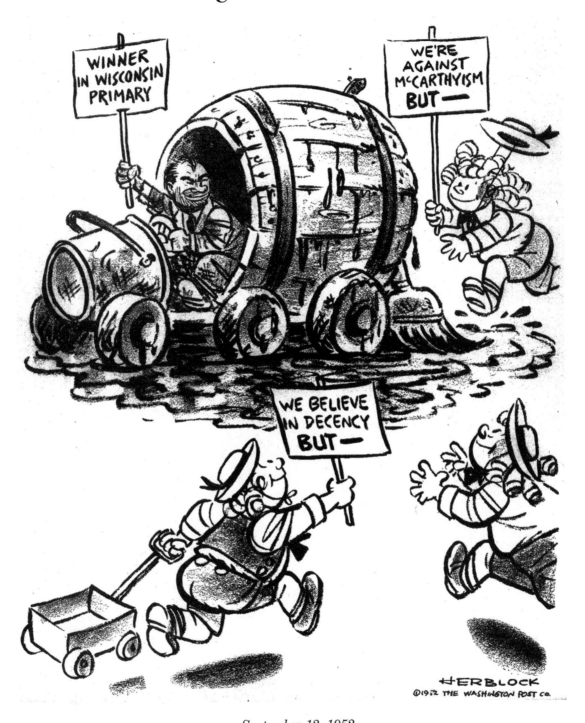

September 12, 1952

SENATOR Joseph McCarthy's irresponsible tactics were endorsed by many voters who felt that the Communist threat was such that the means justified the ends. Other politicians jumped on his tar-barrel bandwagon. They attacked the Truman administration, even as President Harry Truman was fighting a war against Communist aggression in Korea.

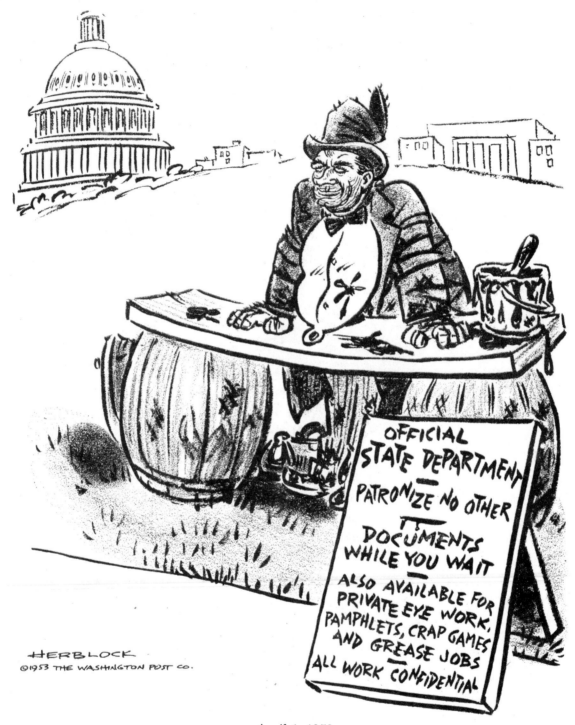

April 1, 1953

"FOR all the talk about McCarthy being a political lone wolf, he was never really alone and couldn't have achieved his peculiar success alone," wrote Herblock. "What sustained him was the tacit support of 'respectable' people who found it advantageous to go along with him, or at least to look the other way. They were the ones who kept him going."

"You Read Books, Eh?"

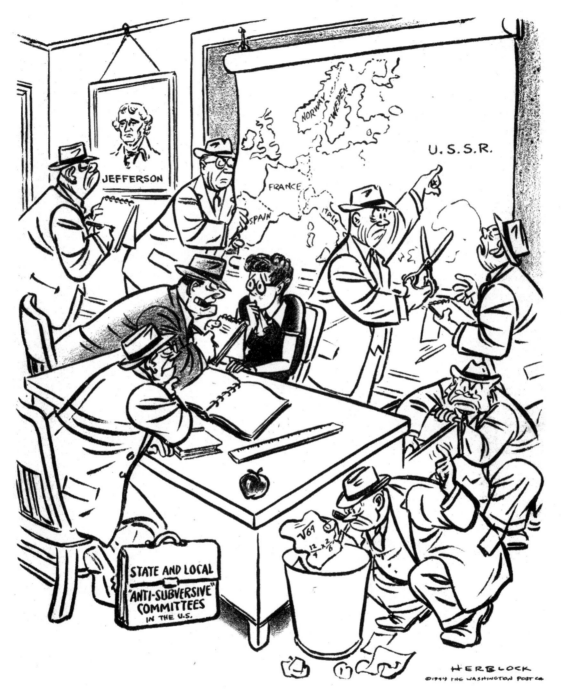

April 24, 1949

DURING the anti-communist campaign, hundreds of elementary and high school teachers were investigated and lost their jobs, sometimes as a result of being named as subversives. Some individuals circulated their own blacklists, which were accepted by frightened employers. The motives of some self-serving or vindictive accusers were summed up by Herblock: "If you can't crush the commies, you can nail a neighbor."

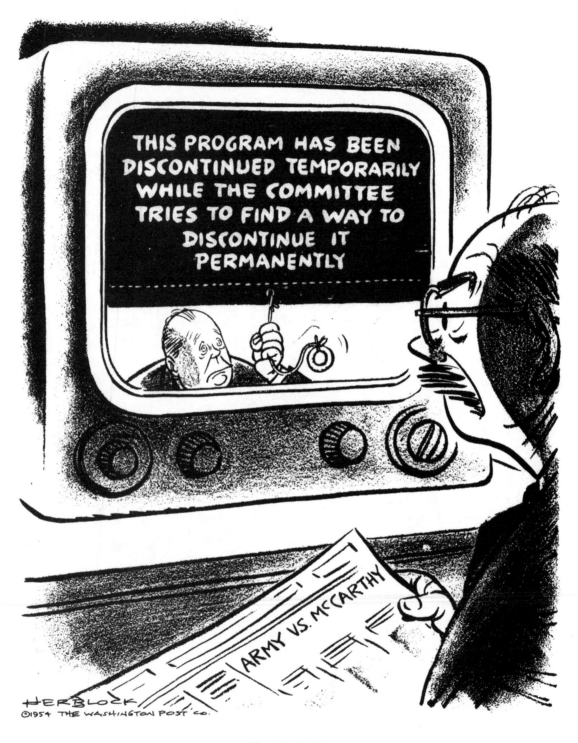

May 20, 1954

ALTHOUGH Senator McCarthy made political gains attacking such prominent Americans as President Harry Truman and former Secretary of State Dean Acheson, he went too far with his 1954 investigation of disloyalty within the U.S. army. For the first time his hearings and reckless, unaccountable tactics were televised. Repercussions were immediate as the hearings were shut down.

"That's the Kind We Want—You Can See Just What He's Not Thinking"

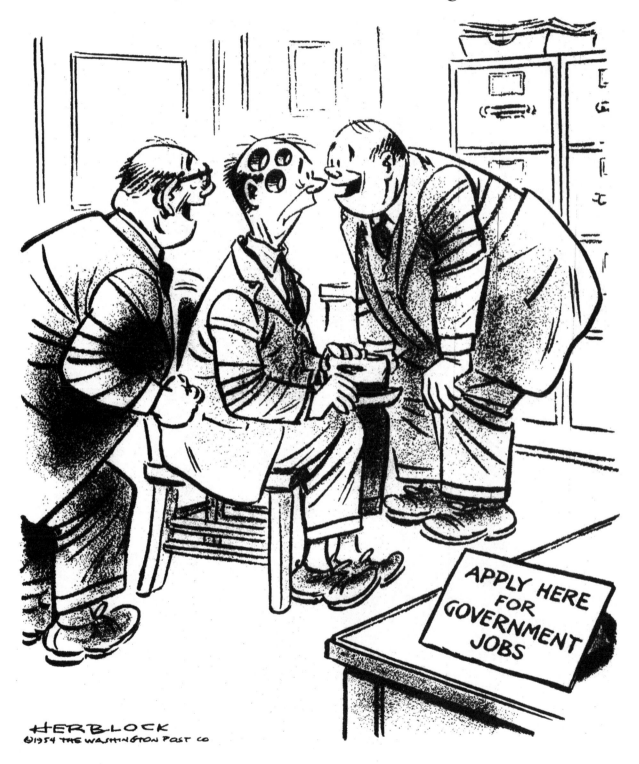

December 29, 1954

"Stand Fast Men. They're Armed With Marshmallows"

August 11, 1954

EVEN with Senator Joseph McCarthy on the wane, the general hysteria aroused by assorted super patriots continued in many forms. In the summer of 1954, a branch of the American Legion denounced the Girl Scouts, calling the "one world" ideas advocated in their publications "un-American."

"Well, Why Doesn't He See A Psychiatrist?"

June 10, 1954

HERBLOCK understood that Joseph McCarthy was not crazy, simply opportunistic, but in the end he had to be stopped. He wrote that "the challenge was faced by those witnesses before the McCarthy committee who refused to be intimidated; by those newspapers and commentators that would not be silent...and by people who...spoke up for themselves and for common decency as individual Americans."

"Relax—He Hasn't Got To You Yet"

March 7, 1954

HERBLOCK considered President Eisenhower among those who could have stopped McCarthy but never tried. Eisenhower treated McCarthy with kid gloves and only publicly spoke out strongly against his activities after the Army–McCarthy hearings. But diarist James Hagerty recorded

Eisenhower's private thoughts: "This guy McCarthy is going to get into trouble...I'm not going to take this one lying down....He wants to be President. He's the last guy in the whole world who'll ever get there, if I have anything to say."

"Have A Care, Sir"

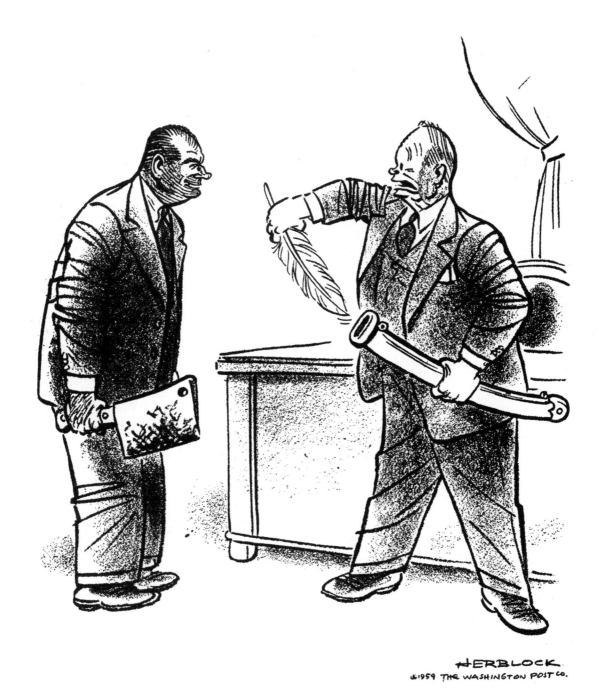

March 4, 1954

THROUGHOUT his political career, Dwight Eisenhower refused to take a public stand against Senator Joseph McCarthy. After half a dozen Republican senators, including Ralph Flanders, joined Margaret Chase Smith in a "declaration of conscience" against McCarthy, Eisenhower continued to speak of "justice and fair play" in fighting Communism.

The Recording Angels

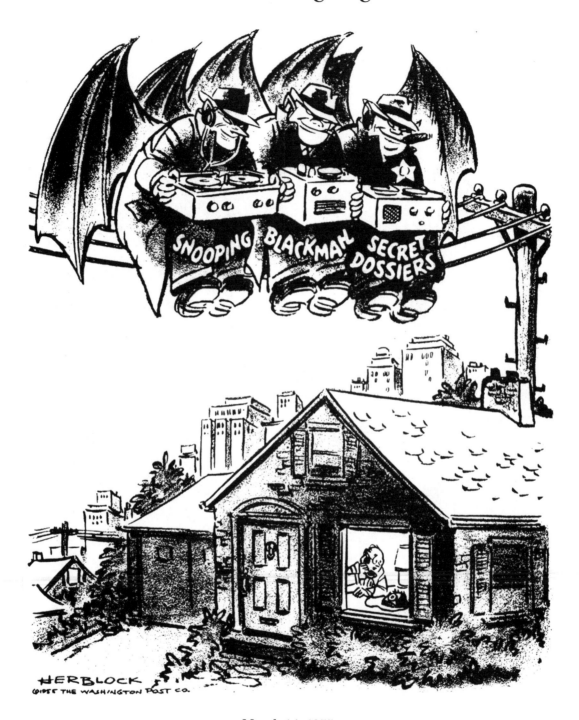

March 14, 1955

I N 1955, Herblock wrote: "The Attorney General of the United States, in his boundless zeal to protect the government from anything which protects the rights of individuals, has modestly requested that he be empowered to authorize taps on telephones." At this time, the Eisenhower administration argued that the fear of Communism justified investigating American citizens.

"Carry On, Lads"

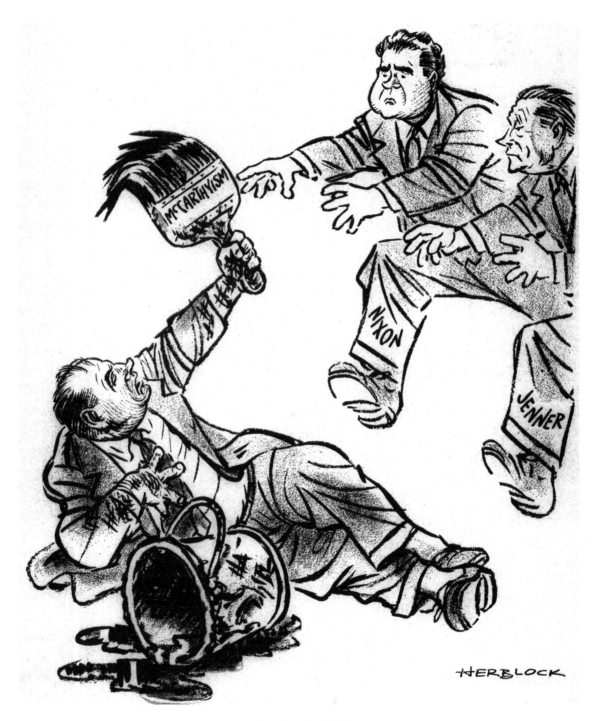

October 7, 1954

HERBLOCK depicts politically battered Senator Joseph McCarthy handing off the tar brush of "McCarthyism" to Republican colleagues: Senators Richard Nixon of California and William Jenner of Indiana.

Herblock on Civil Rights

The long and often bloody struggle to achieve full equality for all citizens had no more effective advocate than Herblock, as these cartoons memorably show. He takes on the scourge of poverty and slums that breed inequity and public discontent, cowardly politicians, biased Jim Crow unions, slumbering senators, the stark disparity of opportunities that exists in inner-city public schools contrasted with the far greater advantages of schools in the prosperous suburbs. But the greatest power of the cartoons reprinted in this section can be seen in Herblock's searing portrayal of segregationists, thugs, and Ku Klux Klan lynchers who employed violence, even murder, to maintain America's segregated society.

The civil rights movement reached its peak during his years as a syndicated cartoonist. It was a time of battles over rights fought on streets and inside courtrooms, both state and federal, of bus boycotts and passive resistance demonstrations, and of legal rulings that ultimately struck down the laws that made segregation possible. It was also a time of villains and heroes, blatant discrimination throughout all levels of U.S. society, voter registration drives and marches intended to be nonviolent that ended in beatings and bloodshed. Towering over this historic period was the figure of Martin Luther King Jr., whose ideals survived even after his assassination ignited riots throughout America. And always in the background was the question, as Herblock posed it, of whether racial progress could outpace the threat of violence that accompanied it.

"Not Guilty"

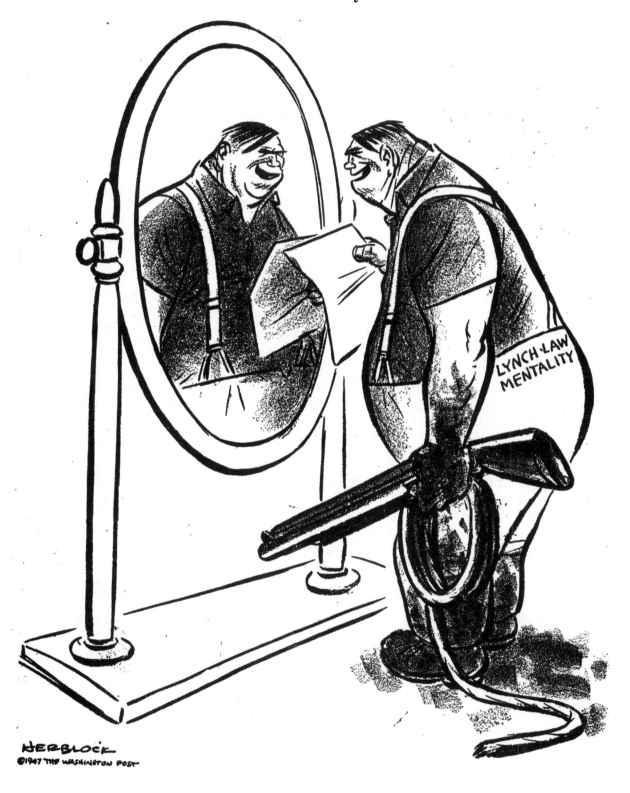

May 23, 1947

Room With A View

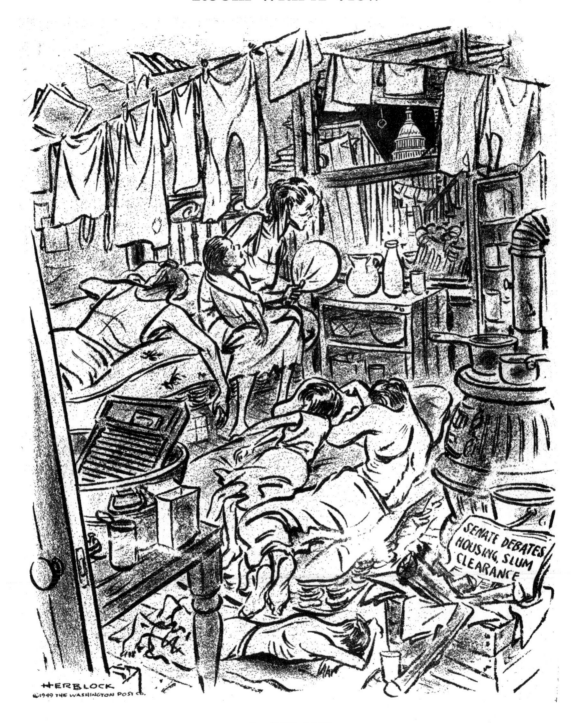

April 22, 1949

IN post-World War II in the U.S., the American dream of affordable housing and education were realized by many. Yet despite efforts to clear slums and replace them with low-cost public housing, inequities continued to exist in America's cities. Herblock commented: "The contrasts are particularly noticeable in the nation's capital, where a well-housed Congress dominates attempts at self-rule."

School Bell

HERBLOCK
©1954 THE WASHINGTON POST CO.

May 19, 1954

ON May 17, 1954, the United States Supreme Court ruled that public school segregation was unconstitu- tional, in the case *of Brown v Board of Education of Topeka, Kansas*. Let freedom ring.

"Somebody From Outside Must Have Influenced Them"

February 28, 1956

SEGREGATION of buses in Montgomery, Alabama, was challenged in 1955 when Rosa Parks was arrested for refusing to relinquish her seat. Parks's arrest sparked a city-wide bus boycott by blacks which lasted for more than a year. It ended when the Supreme Court compelled the city to end segregated public busing and allowed Montgomery's black citizens to choose their own seats.

"Pull Over To The Curb"

November 16, 1956

"Tote Dat Barge! Lift Dat Boycott! Ride Dat Bus!"

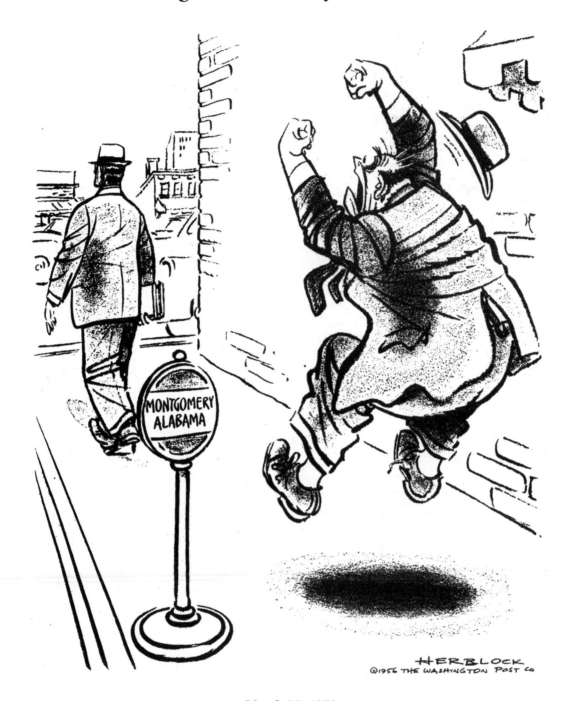

March 25, 1956

THE Montgomery bus boycott was an immediate success, with 90 percent of African Americans in Montgomery finding alternative sources of transportation. The boycott continued into 1956, despite harassment, physical abuse and jailing of blacks.

Finally, on November 13, 1956, the Supreme Court declared segregated seating on buses unconstitutional. Herblock's title refers to lyrics from the *Showboat* song, "Ol' Man River."

"Tsk Tsk—Somebody Should Do Something About That"

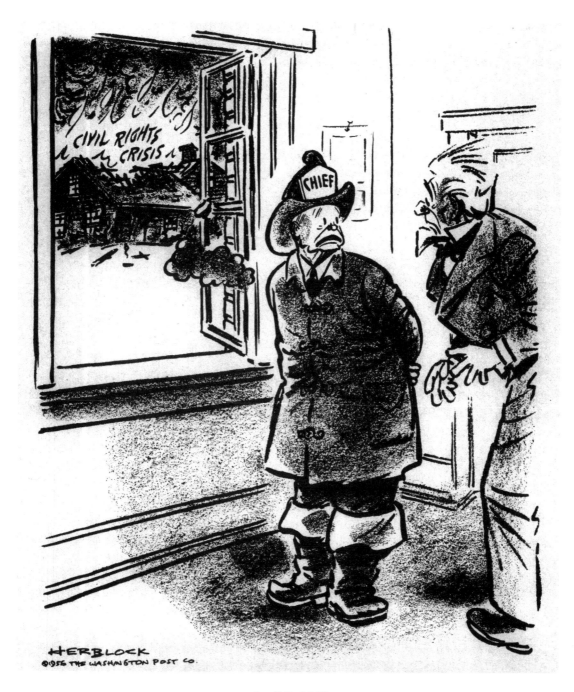

April 3, 1956

AMONG Herblock's criticisms of the Eisenhower administration was the lack of support for the Supreme Court's 1954 school desegregation ruling. Eisenhower lamented that "you can't change the hearts of men by laws." The leadership vacuum allowed time for the organization of white citizens' councils and of massive white resistance. In 1956, Eisenhower's view on integration was that it should proceed more slowly.

"Nah, You Ain't Got Enough Edjiccashun To Vote"

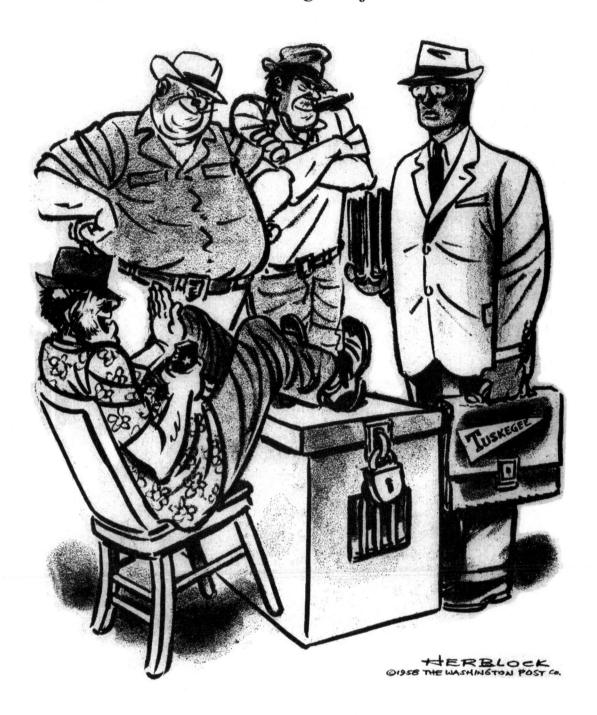

December 10, 1958

HERBLOCK caught the irony in ignorant Southern racists denying educated blacks their right to vote. The Tuskegee Institute, mentioned here, was one of the South's foremost institutions of higher learning. During World War II, African Americans who trained as pilots at the institute gained military fame as the courageous Tuskegee Airmen

Poplarville, Mississippi, U.S.A., 1959

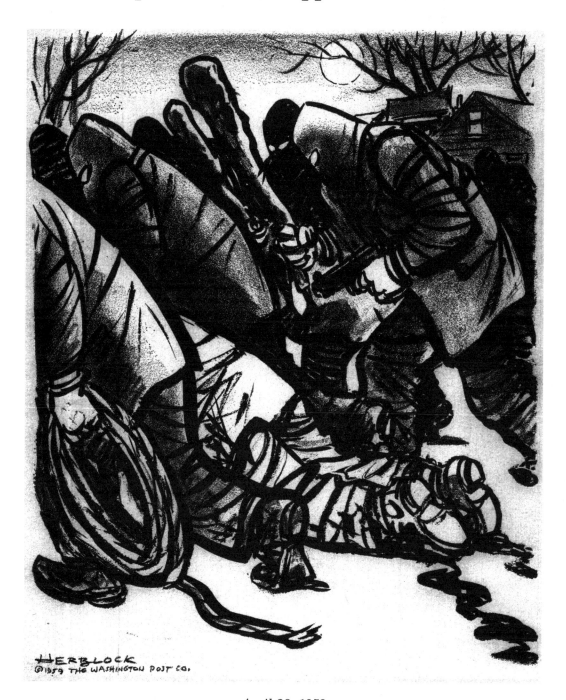

April 28, 1959

ALTHOUGH in the 1950s some progress was made toward attaining civil rights for African Americans, lynchings continued until the late 1960s. On April 25, 1959, a group abducted Charles Parker from prison in Poplarville, Mississippi, where he awaited trial on charges of raping a white woman. On May 4, the FBI found his body in the Pearl River near Bogalusha, Louisiana; he was executed with two bullets.

"Pray Keep Moving, Brother"

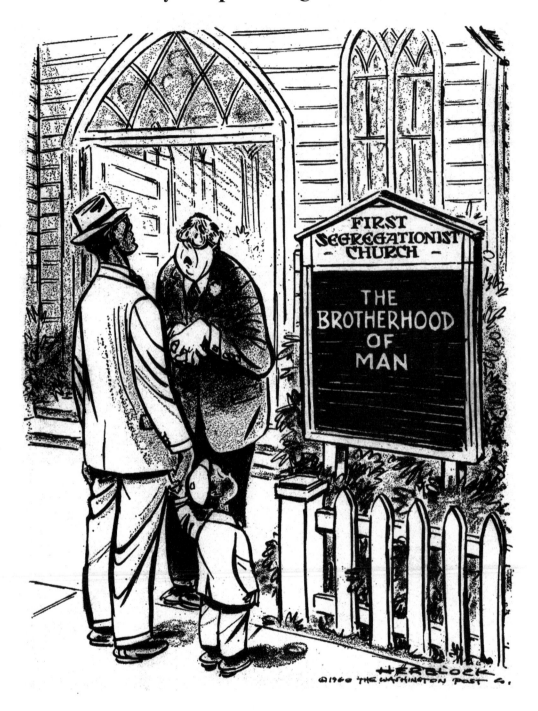

August 14, 1960

AS the civil rights movement heated up in the 1960s, black Americans cultivated the technique of peaceful protest, using it in dignified and disciplined demonstrations against segregation at lunch counters and other places. Here Herblock focuses on the ultimate irony of segregation in places of worship preaching the brotherhood of man.

"It's All Right To Seat Them. They're Not Americans"

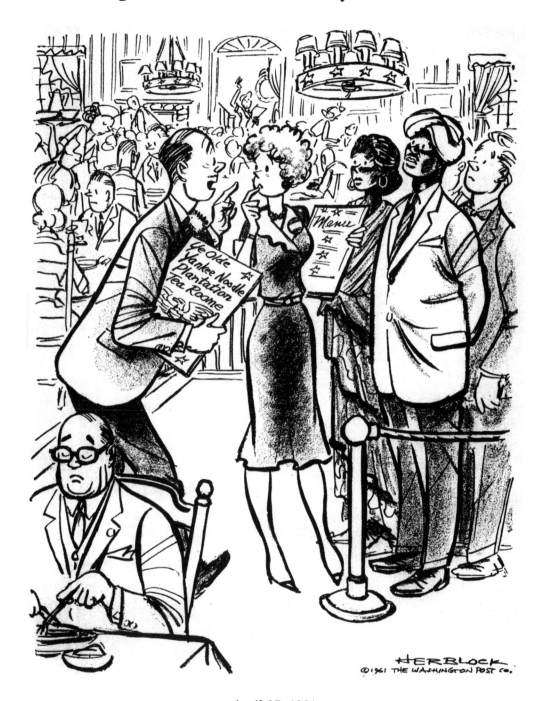

April 27, 1961

PRESIDENT John F. Kennedy called for southern governors to assure "a friendly and dignified reception" for foreign diplomats visiting the United States, amid widespread discrimination against blacks in restaurants and other public places.

Herblock's cartoon, based on an actual occurrence, expressed the outrageousness of black Americans in the United States being held as less worthy of respectful treatment than foreigners.

"We Don't Want No Troublemakers From The United States"

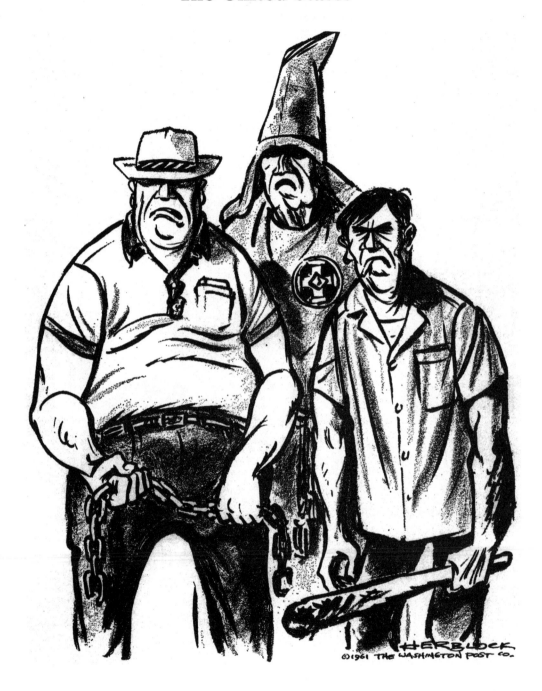

May 23, 1961

HERBLOCK used depictions of three armed thugs to criticize the mob that attacked the Freedom Riders—seeking integration of public transportation—in Montgomery, Alabama on May 21, 1961. The title, an adaptation of a quote from the city's Police Commissioner, implied that the South's sense of justice differed from that of the rest of the U.S.

Higher Education In Mississippi

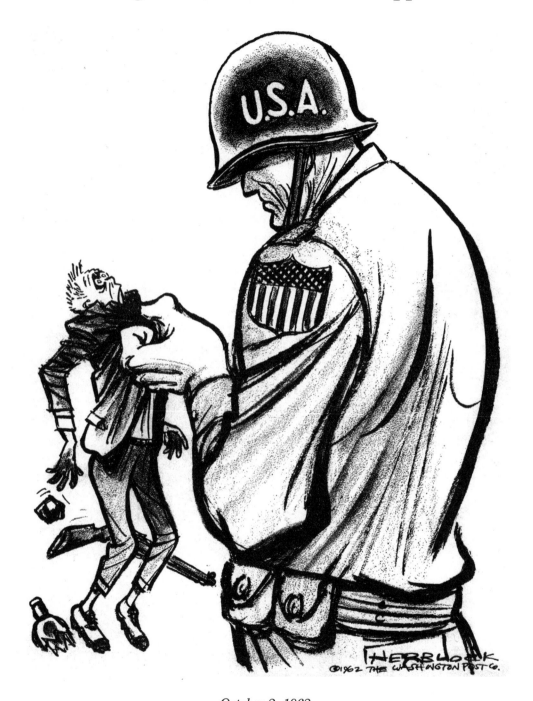

October 2, 1962

IN the winter of 1961, Mississippi student James Meredith applied for a transfer from all-black Jackson State College to the University of Mississippi. After first being denied admission eventually, he was allowed to enroll secretly, but his presence on campus sparked a riot. The intervention of federal troops was needed to guarantee his safety on campus. Meredith went on to complete his education at Ole Miss, graduating in 1964.

"What's the Matter? We Don't Say 'Niggers' Up Here"

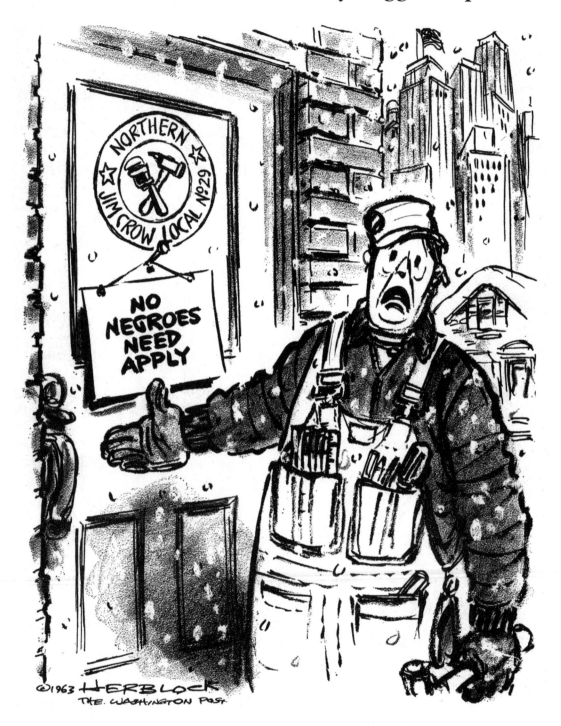

March 12, 1963

HERBLOCK never pulled his punches when it came to race relations or hypocrisy. Northern union shops were often closed to black workers, their apparently unbiased hiring practices restricted by unwritten policies.

"Those Alabama Stories Are Sickening. Why Can't They Be Like Us And Find Some Nice, Refined Way To Keep The Negroes Out?"

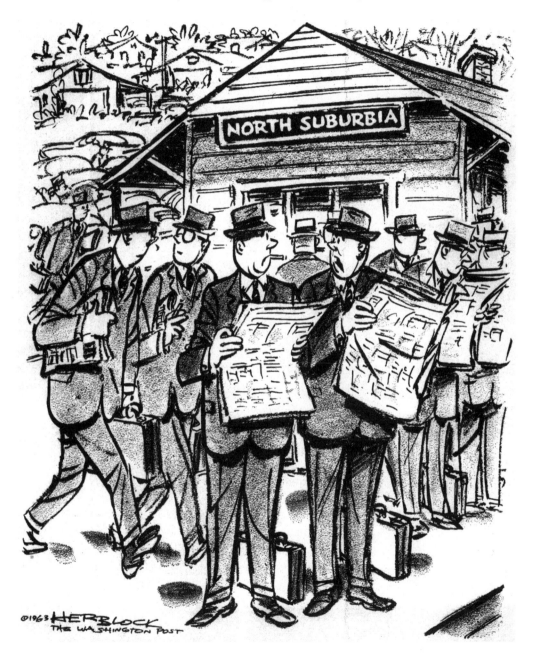

May 19, 1963

HERBLOCK knew that racism in America was not confined to section, political party, ethnic group, or socio-economic class. In the Northeast, well-off white, "white-collar" citizens were often considered more liberal, perhaps due to the regional history of abolitionism, yet Herblock belies that notion in this startling take on prosperous urban commuters discussing the race problem in the South.

"Sorry, But You Have An Incurable Skin Condition"

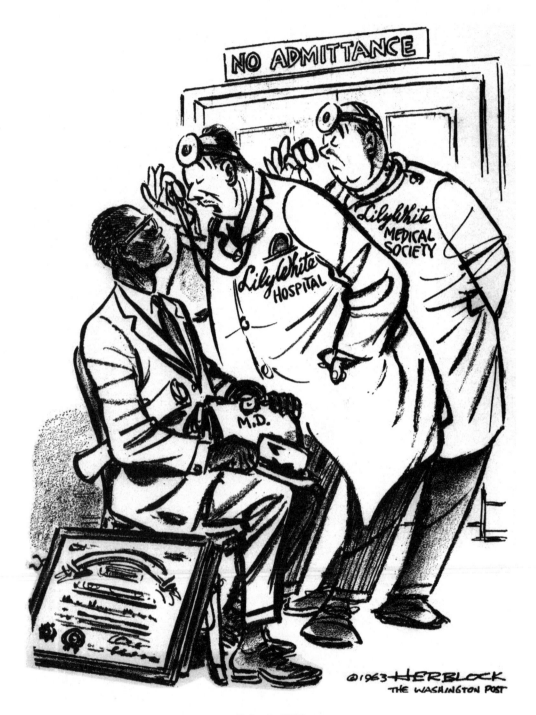

July 4, 1963

IN many areas, black doctors were excluded from practice in medical facilities, not only depriving them of opportunities, but depriving many patients of all colors of treatment they might have received.

In 1963, the American Medical Association and a black medical association agreed to form a joint committee to halt injustices toward black doctors.

Ten.
"I'm ~~Eight.~~ I Was Born On The Day Of The Supreme Court Decision"

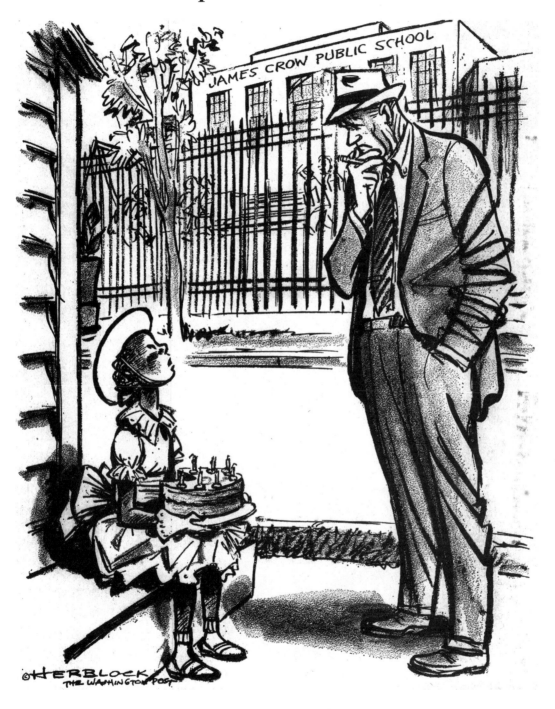

May 17, 1964

IN 1964, still frustrated by the United States' government's slow progress toward providing equal voting and civil rights for all its citizens, particularly African Americans, Herblock reissued his classic 1962 cartoon, simply crossing out the eight and replacing it with a ten.

Continuation Of A March

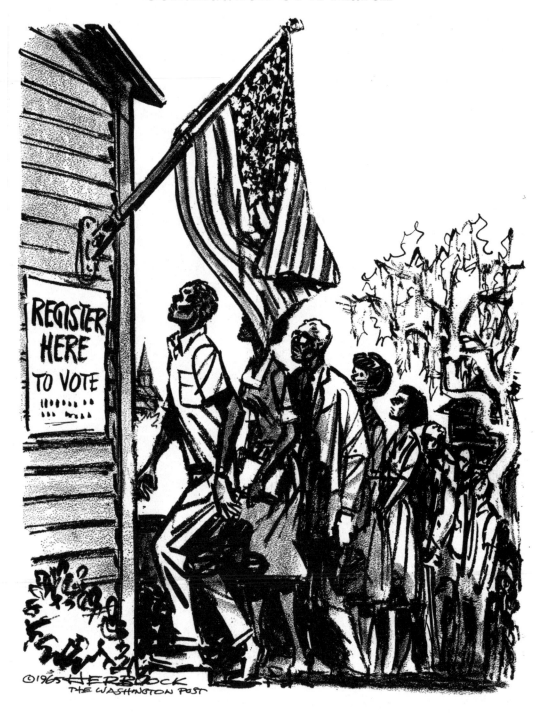

August 11, 1965

PRESIDENT Lyndon Baines Johnson signed the Voting Rights Act of 1965 on August 6th, landmark federal legislation prohibiting states from imposing a "voting qualification or prerequisite to voting, or standard, practice, or procedure...to deny or abridge the right of any citizen of the United States to vote on account of race or color."

Jericho, U.S.A.

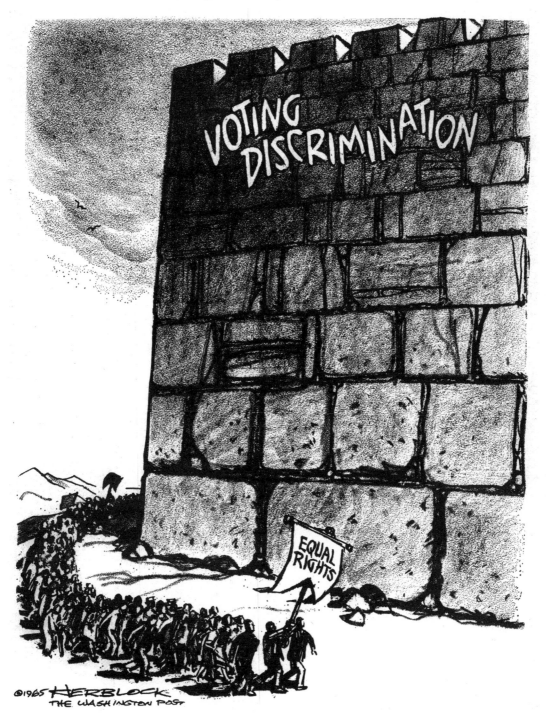

March 21, 1965

HERBLOCK compares the civil rights marches around the exclusionary walls of segregation to the Biblical march of the exiled ancient Israelites around the walled city of Jericho. The Israelites marched around Jericho seven times and the walls came tumbling down.

Enemies of the Dream

Race

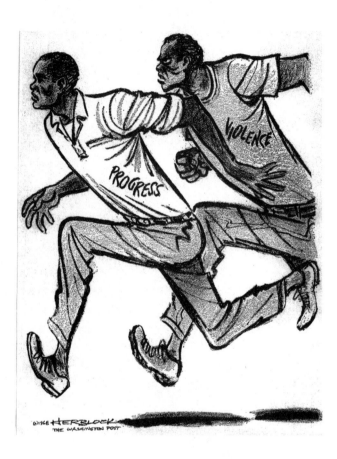

April 7, 1968

ON April 4, 1968, the assassin James Earl Ray shot civil rights leader Martin Luther King, Jr. dead as King stood on a balcony at the Lorraine Motel in Memphis, Tennessee. The murder sent shock waves through the world, making a martyr of King and causing race riots across America.

May 28, 1968

HERBLOCK asks which black man will emerge from the civil rights movement, one who is educated and enfranchised, or angry and embittered. On April 6, two days after the assassination of Martin Luther King, Jr., race riots broke out in several American cities and the National Guard had to be called in to quell the riots.

"...One Nation...Indivisible..."

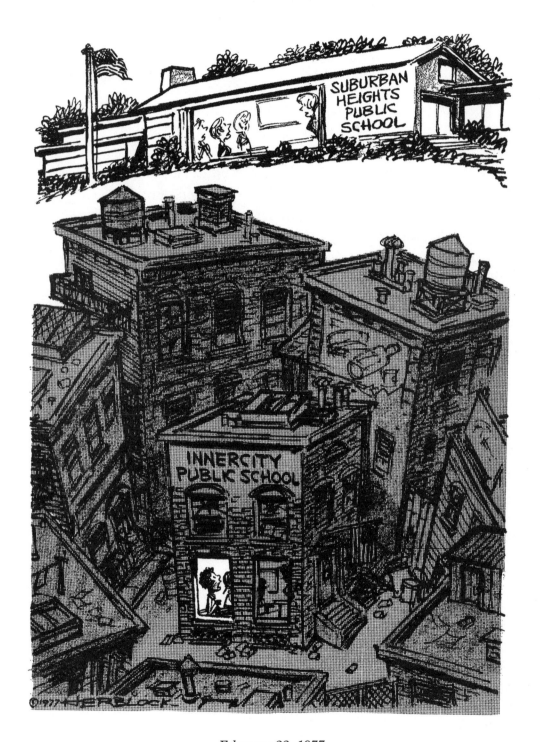

February 22, 1977

DURING the 1970s the flight of whites from urban centers to suburban communities in the wake of race riots left vast gaps in city taxes, which could fund social services and education for those left behind.

Herblock and the Sixties

Nearly half a century has passed since the United States experienced the cultural ferment of the sixties, but the aftershocks of that tumultuous decade still affect the attitudes and behavior of the country. These were the years of John Kennedy and the promise of his New Frontier, of Lyndon Johnson and his Great Society, and of early hopes that America was entering a golden age of peace and prosperity. Those hopes were cruelly dashed by the disasters that struck America: assassinations, the Vietnam War, racial riots, antiwar protests, all adding up to the most divisive time the United States had experienced since the Civil War a century before. The issues of the day affected attitudes about race and class, created conflicts among generations and regions, pitted groups against groups, and launched the "culture wars" that have influenced political battles since.

In the wake of the JFK assassination, the Democratic Party rose to its peak of public favor, setting the stage for LBJ's liberal agenda that led to changes in voting rights, the end of legal segregation, and reforms advancing rights for women, Native Americans, and other minorities. All this came about after Barry Goldwater's crushing defeat in the 1964 presidential election.

Then Democrats fell into such disfavor that they proceeded to lose seven of the next ten elections. A recurrent theme of Herblock's portrait in this period is his passionate attack on the gun lobby. His "SPORTSMEN! KIDS! MANIACS!" cartoon showing a "dandy imported rifle with regular 'sharpshooter' telescopic sight" costing only $12.78 that could be shipped "direct to *you* almost anywhere in the U.S." appeared five days after John F. Kennedy's assassination. The weapon portrayed was the same kind used to kill Kennedy in Dallas. Herblock's depiction of the hopes and fears of that decade encompassed efforts to achieve a test-ban treaty to diminish nuclear threats. His drawings contin-

ued to call attention to unfairness and distress in the America of both rich and poor, to increasing strains on budgets and spiraling debt, to the ever present presence of racism. The calamities of the sixties reached a destructive peak in 1968 after both Martin Luther King Jr. and Robert Kennedy were slain, creating the emotional setting for that summer's Chicago Democratic presidential convention, when Chicago police took off their badges and waded into antiwar protesters and clubbed them to the ground. Two other recurrent Herblock themes are displayed in his warnings of trampling on basic rights through governmental wiretaps and illegal surveillance and of the collision between domestic and military spending portrayed with great effect in his cartoon labeled "The Mini-and-Maxi Era."

Split-Level Living

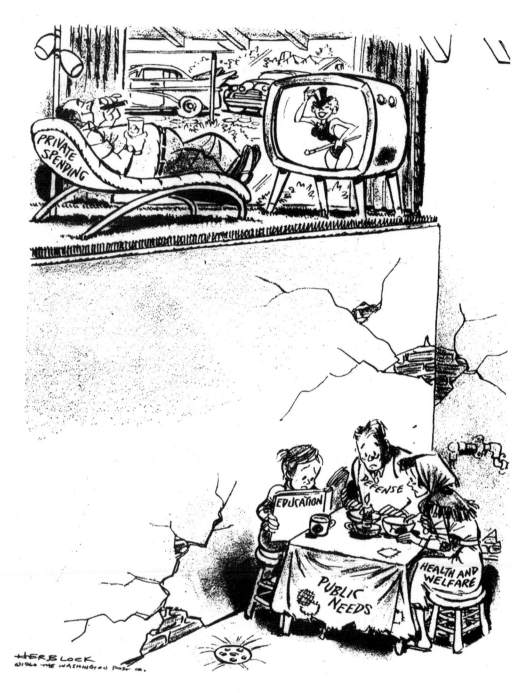

March 9, 1960

FOLLOWING World War II, construction of single-family housing exploded in suburbia, the "split-level" house being one of the more popular models. By 1960, personal income had reached all-time highs. Yet critics said President Dwight Eisenhower had failed to provide more spending needed for education and for economic and social programs, especially for those Americans left out of the general prosperity.

"I help to support the establishments I have mentioned; they cost enough, and those who are badly off must go there."

— A Christmas Carol

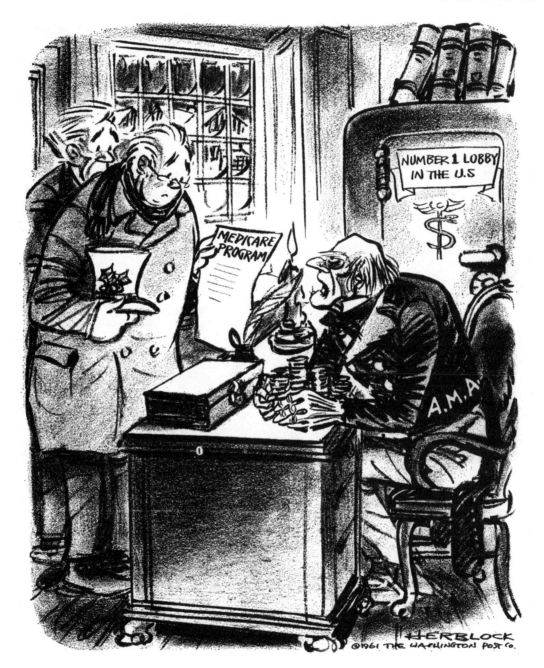

November 29, 1961

PRESIDENT John F. Kennedy proposed legislation to use payroll taxes to support medical care for the aged. Dr. Leonard Larson, president of the American Medical Association, spoke against what would eventually become Medicare, predicting that it foretold the complete socialization of medical care in the United States. Larson reminded Herblock of the miserly Scrooge in Dickens' *A Christmas Carol.*

"If You Had Any Initiative, You'd Go Out And Inherit A Department Store"

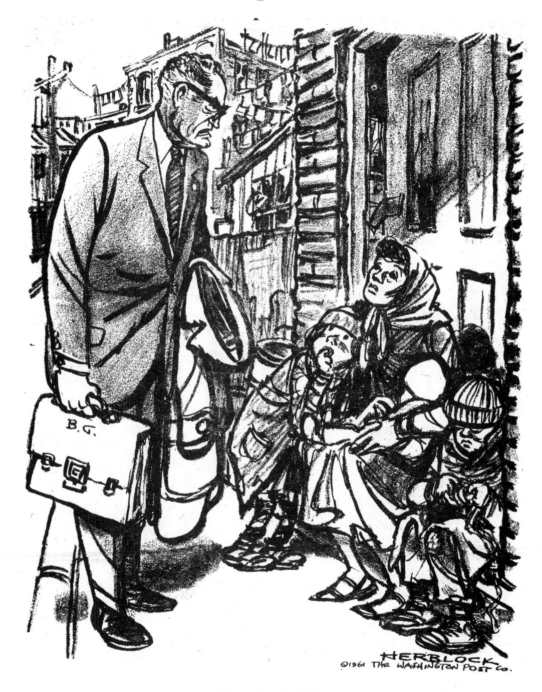

December 6, 1961

BARRY Goldwater (1909–1998) served the state of Arizona as a five-term United States Senator (1953–1965, 1969–1987), forging a career as one of the nation's most influential conservative politicians.

His father, Baron Goldwater, founded Goldwater's, a successful department store in Phoenix, which Barry inherited upon his father's death in 1930.

Washington, D.C., June 1963

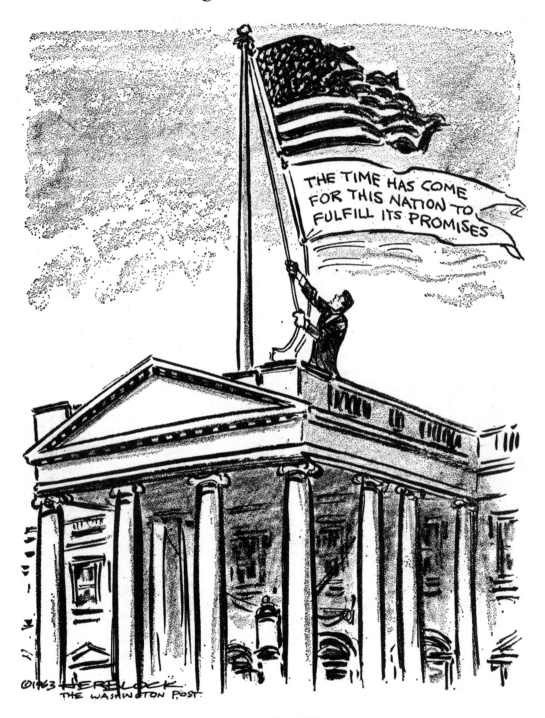

June 13, 1963

IN spring 1963, Alabama Governor George Wallace refused to allow two black students to enter the University of Alabama. U. S. President John F. Kennedy called out the state National Guard to protect the two students. He then made a landmark televised address to the American people on June 11, 1963, pledging action on behalf of African Americans and setting the stage for future legislation.

"I Still Can't Believe It"

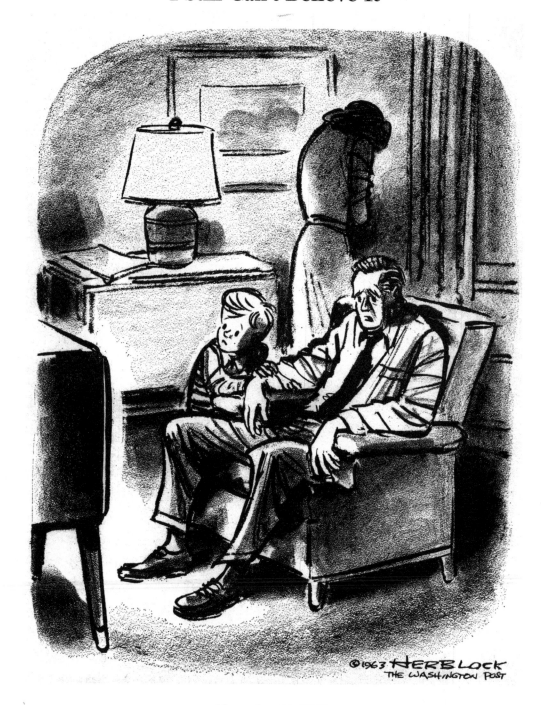

November 24, 1963

THE most prevalent reactions among people the world over to the assassination of President John F. Kennedy in Dallas, Texas by Lee Harvey Oswald were shock, horror, sadness and denial. In 2003, television news anchor Bob Schieffer, assigned to the JFK assassination as a young reporter for the *Forth Worth Star-Telegram* recalled the event as, "the most draining story from an emotional standpoint that I had ever covered. It was not until 9/11 that I ever felt again the way I felt in the aftermath of that."

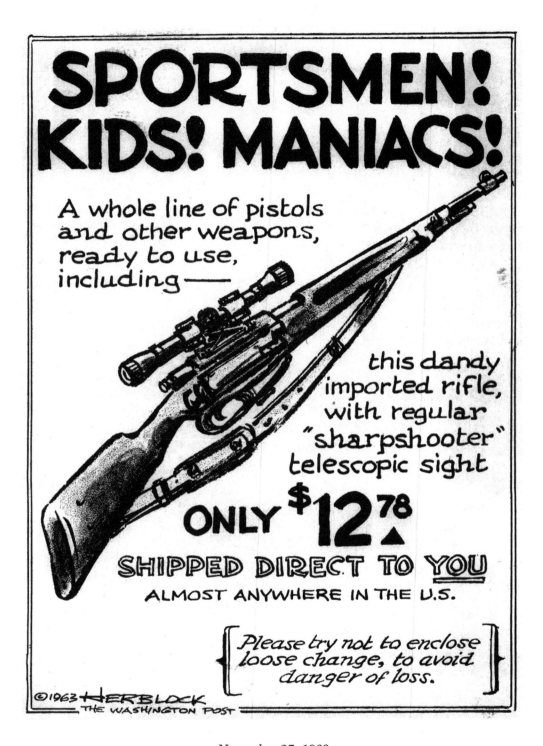

November 27, 1963

ALREADY a strong supporter of gun control legislation by the early 1960s, Herblock took the tragic opportunity of President John F. Kennedy's assassination to remind Americans that lax gun laws may have contributed to the president's death. With typical attention to detail, Herblock depicts the actual gun used by Lee Harvey Oswald to kill JFK: a 6.5 mm caliber Carcano rifle.

Cigaret Box

January 14, 1964

HERBLOCK foresaw many issues, including the anti-smoking campaign. In 1959, he suffered a heart attack and after six weeks in the hospital quit what had been a multi-pack-a-day habit. In his 1993 memoirs, he wrote, "with the health hazards increasingly obvious and tobacco companies showing a callous irresponsibility, it was clearly an issue worth working on."

"Our Position Hasn't Changed At All"

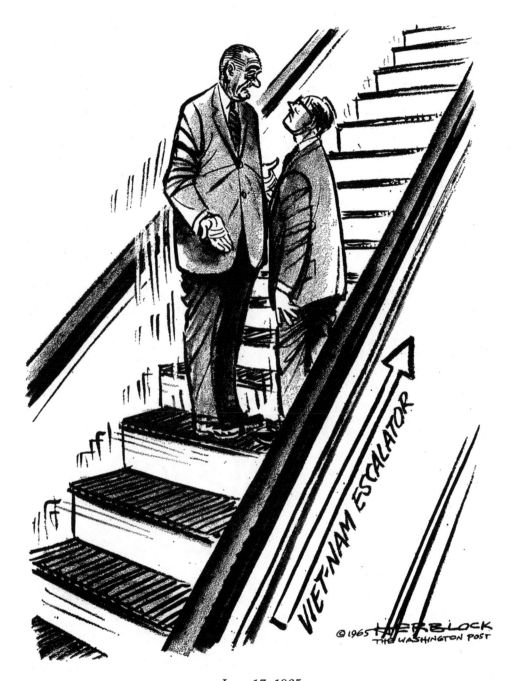

June 17, 1965

AFTER the U.S. State Department announced the possibility of a direct American combat role in Vietnam, the White House issued "clarifications," insisting that there had been no change in policy. On June 16, 1965, the Defense Department announced that 21,000 additional soldiers would go to Vietnam, bringing the total U.S. presence to more than 70,000 men. President Lyndon Johnson continued to obscure the extent of American involvement, contributing to a widespread perception of political untrustworthiness.

"As Nearly As We Can Translate, It Says:
'We Are Agreed In Principle On Preventing The Spread Of Nuclear Weapons; However…'"

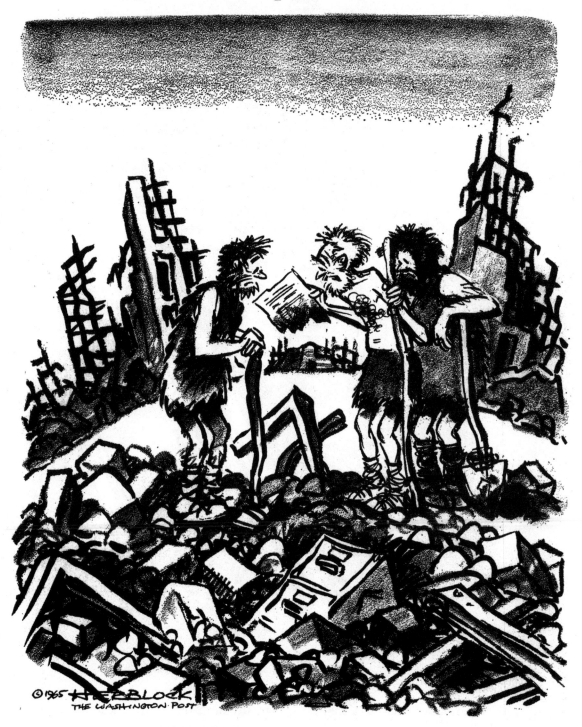

November 10, 1965

Prisoners Of War

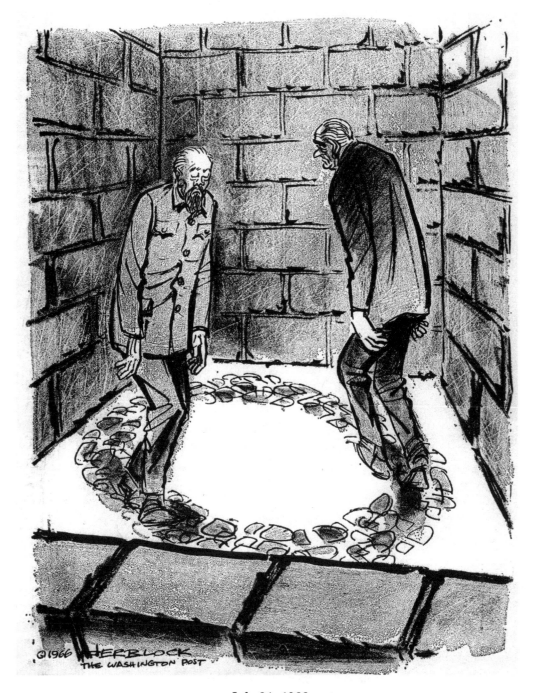

©1966 HERBLOCK
THE WASHINGTON POST

July 21, 1966

BY mid-1966 almost 200,000 U.S. troops were on the ground in South Vietnam, and North Vietnam was receiving arms from the Soviet Union and other Communist countries. North Vietnamese president Ho Chi Minh denounced American peace initiatives, while South Vietnamese officials refused to meet with rebel Viet Cong leaders. U.S. President Lyndon B. Johnson remained stymied throughout his years in office in his attempts to jump start peace talks.

"Everything's Okay—They Never Reached The Mimeograph Machine"

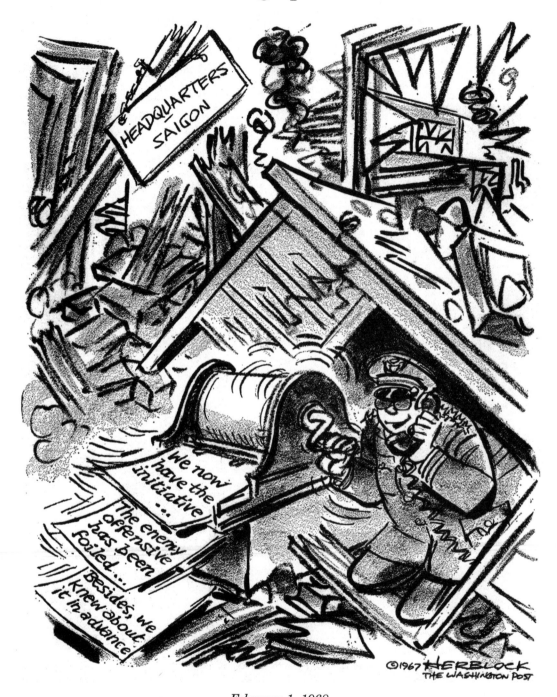

February 1, 1968

"ARGUMENTS raged about the 1968 Tet Offensive, which some observers maintained was the Viet Cong's final all-out effort," said Herblock. "But whatever the military situation, there had been too many misleading reports, too many victories in the offing…and too many Americans brought home in flag-draped caskets for the country to retain confidence in this [LBJ] administration's war policies."

Fiddler

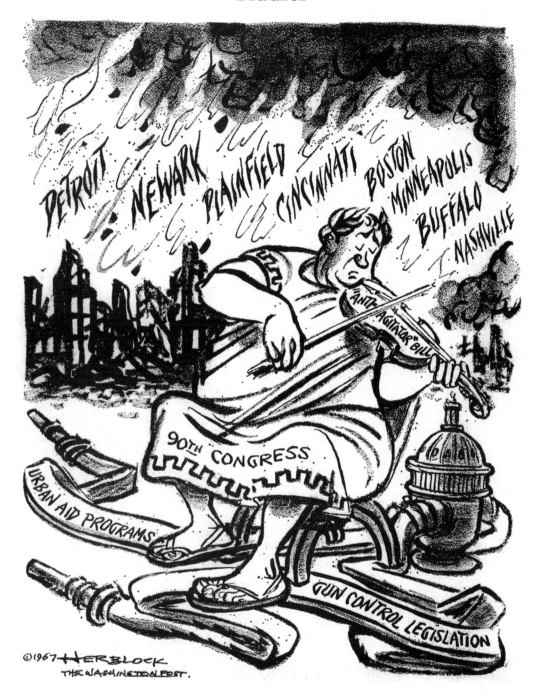

July 25, 1967

ALTHOUGH many Americans were prosperous in 1967, inner city residents, especially blacks experiencing poverty and racial injustice, felt no share in it. During the summer, protests and riots broke out in several American cities. In response, the House of Representatives passed a bill that made it a federal crime to cross state lines to incite a riot. This cartoon portrays Congress in the role of Nero, fiddling while U.S. cities burn.

The Gray Plague

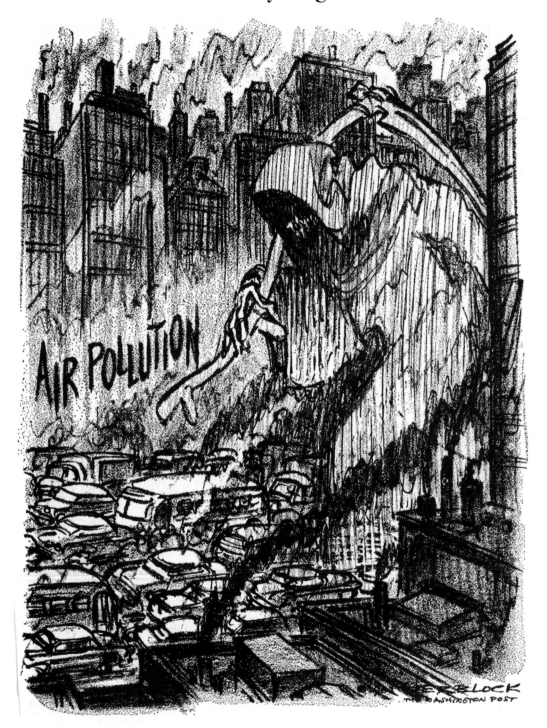

January 29, 1967

WITH his image of the Grim Reaper coming for those who dared to breathe in America's cities, Herblock indicated that air pollution had become a major issue by 1967. President Lyndon Johnson asked Congress to authorize federal regulation of air quality to protect the environment.

Man's Reach

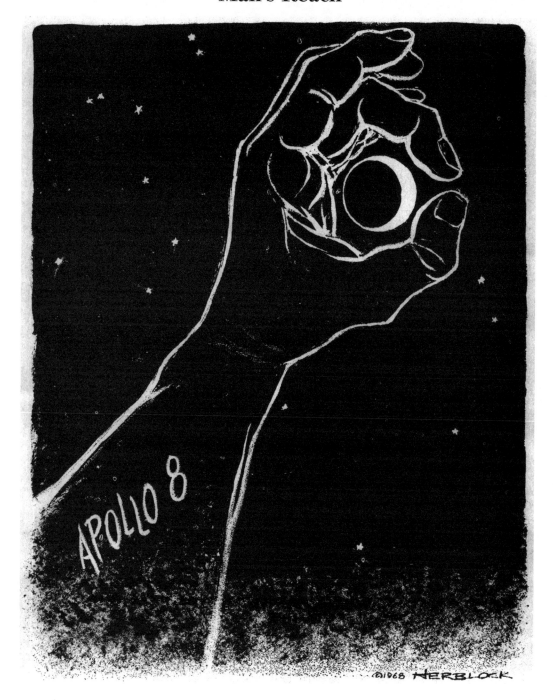

December 26, 1968

APOLLO 8, the second manned mission in the Apollo space program, launched on December 21, 1968, achieving several firsts: the first manned voyage beyond Earth's gravitational pull; the first manned voyage to the moon or any other celestial body; and the first manned voyage to return from the moon or other celestial body. Also, the ship's passengers, astronauts Frank Borman, James Lovell, and William Anders, became the first humans to view the dark side of the moon.

The Hands Still Reach Out

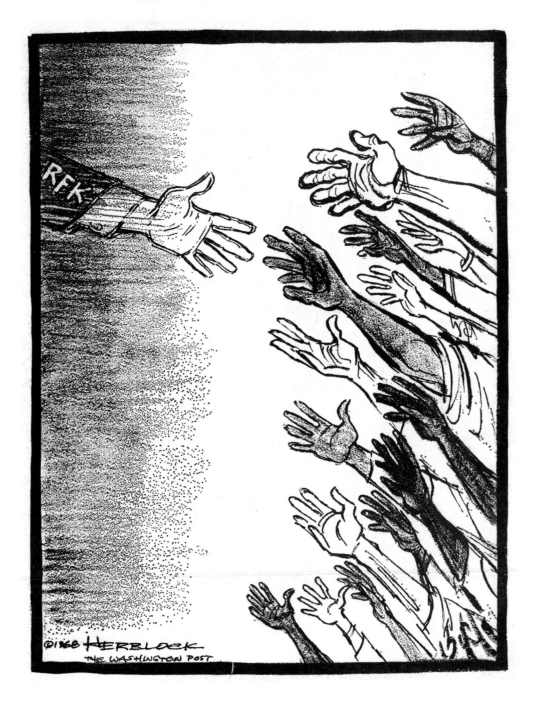

June 7, 1968

SHORTLY after midnight on June 5, 1968, presidential candidate and United States Senator Robert F. "Bobby" Kennedy was shot and killed while celebrating his victory in the California state Democratic primary. Palestinian immigrant Sirhan Sirhan was convicted and incarcerated for killing Kennedy. Kennedy was renowned for his progressive views on civil rights and willingness to wade into large crowds to greet well-wishers.

The Mini-And-Maxi Era

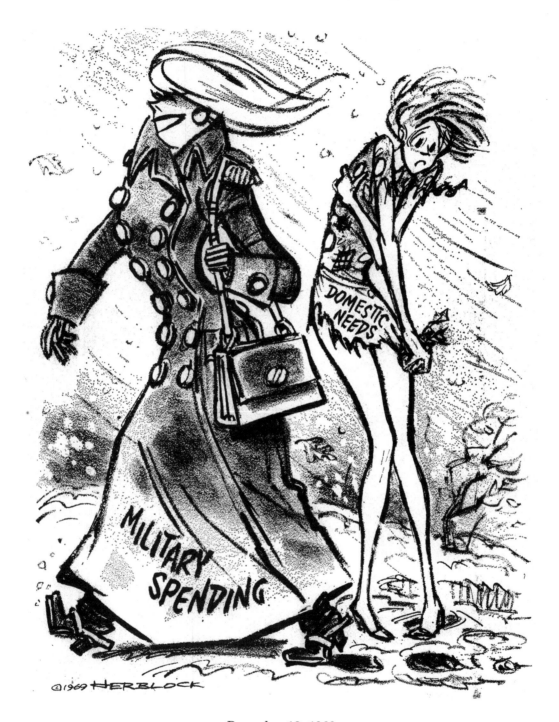

December 18, 1969

"THE antiballistic missile system was the Great New Thing in 1969," observed Herblock. "For a mere 4 or 5 or 6 billions we could get in on the ground floor, which we did. From there on, the costs could go straight up—which they did. It was called a 'thin ABM' system because it was a thin end of a wedge into the U.S. Treasury."

"A Cup Of Black Powder And A Few Rounds Of Ammo? Certainly, Neighbor"

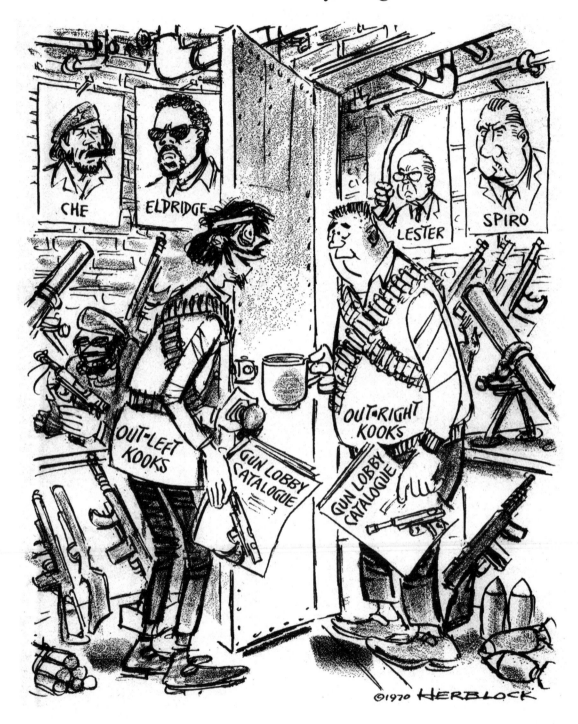

October 8, 1970

HERBLOCK comically captures the criminal common ground between radical extremists on both sides of the racial and political divide during the civil rights era.

"You See, The Reason We're In Indochina Is To Protect Us Boys In Indochina"

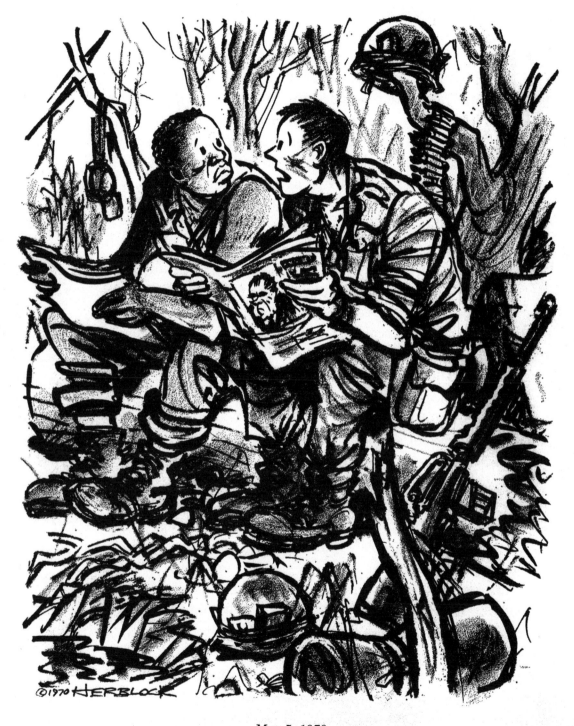

May 5, 1970

DESPITE Richard Nixon's election campaign promises to end the Vietnam War, each new step widened rather than reduced American involvement.

Nixon and Watergate

Never was Herblock's genius shown to greater effect than in his coverage of Richard Nixon and the Watergate scandal. As with Joe McCarthy, Herblock and Nixon were mortal enemies. Although Herblock, in one of his most memorable cartoons, had greeted Nixon's election in 1968 with a famous image showing a barbershop with a sign saying: "This shop gives to every new president of the United States a free shave. H. Block, Proprietor," there was no shortage of criticism in his drawings of the Nixon era from then forward.

The Nixon portrayed here is the gut fighter, the politician who emerges from the gutter to hurl mud on his enemies, the president who presided, as one cartoon put it, over the "White House Horrors" of repeated scandals. The greatest scandal of all, of course, was Watergate. That began when Nixon surrogates were arrested after they were caught in a failed break-in of Democratic Party offices in the Watergate building flanking the Potomac River.

Along with his relentless portrayal of all the Nixon scandals, ultimately leading to the president's forced resignation under threat of impeachment in August 1974, is another favorite Herblock target: J. Edgar Hoover. Hoover was the longtime head of the FBI whose agents were involved in illegal breaking-and-entering episodes as well as wiretapping and bugging operations.

One of Herblock's cartoons serves as timeless epilogue to Nixon and Watergate. It shows the Oval Office being inundated by a flood of water, as Nixon desperately tries to hold onto his desk before being swept away in the torrent. That cartoon bears no headline. Nor does it need one.

On the night of June 17, 1972, former employees of the Nixon reelection campaign broke into the Democratic Party headquarters in the Watergate building. And then...

"We Got To Burn The Evil Spirits Out Of Her"

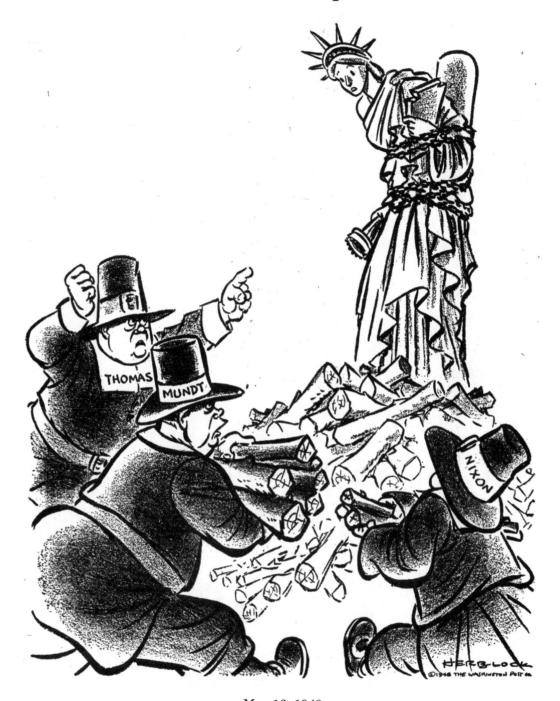

May 16, 1948

RICHARD Nixon's first appearance in a Herblock cartoon occurred in spring 1948 during the first of two consecutive terms Nixon served as a Republican congressman from California. Nixon co-sponsored a bill "to protect the United States against un-American and subversive activities." Herblock portrays he and his colleagues as witch-hunting Puritans putting Lady Liberty, symbol of American civil freedoms, to the torch.

"Now You Kids Beat It"

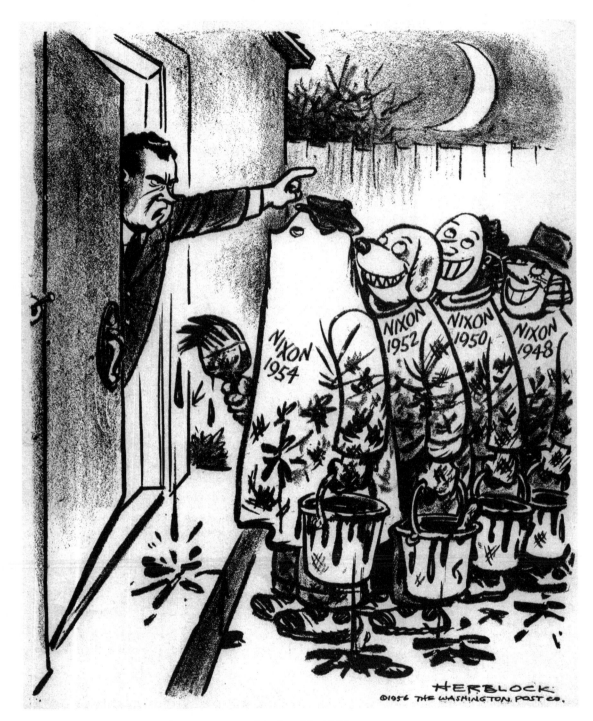

October 26, 1956

THROUGHOUT Richard Nixon's lengthy political career, including the 1956 presidential election when he ran on the Republican Party ticket as President Dwight Eisenhower's running mate, Herblock delighted in reminding voters of the candidate's past scandals and political dirty tricks.

"Of Course, If I Had The Top Job I'd Act Differently"

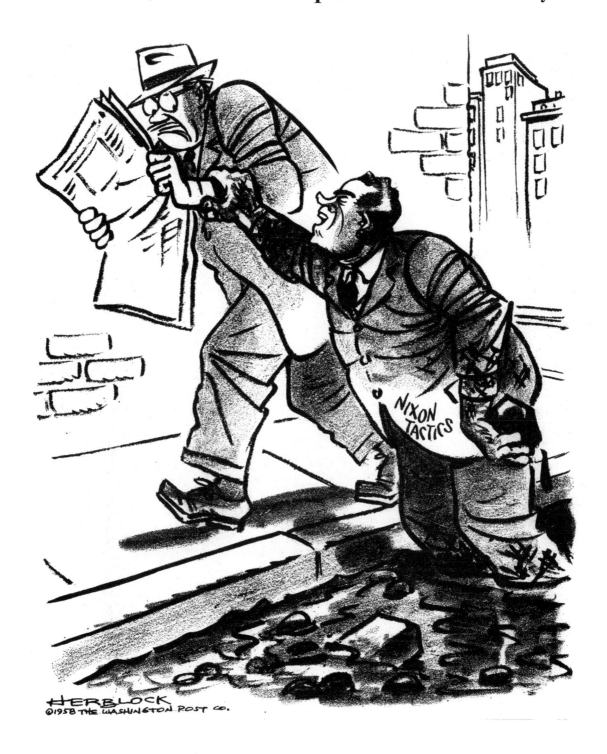

October 16, 1958

EMERGING from the primordial slime of his electioneering activities, Richard Nixon attempts to persuade a leery voter that as president he would clean up his act. In the event, however,...

"What You Need Is Something New, Like This"

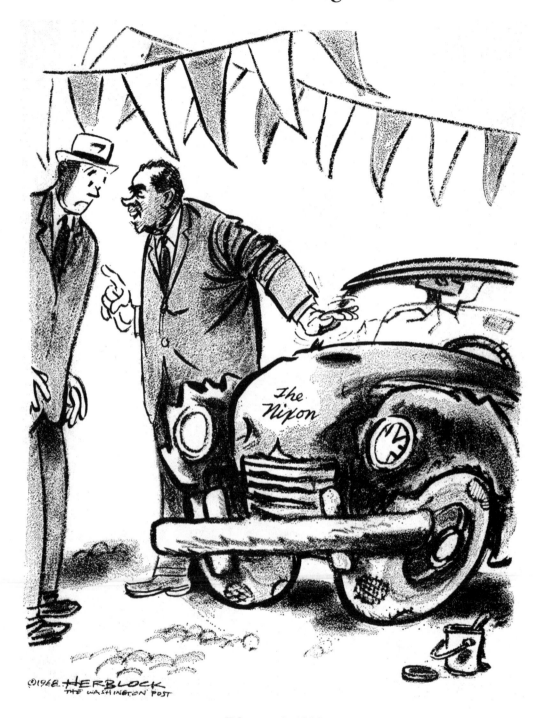

February 2, 1968

IN the run-up to the 1968 presidential election, Herblock asked American voters, "Would you buy a used car from this man?" Later he wrote: "I was long identified as 'anti-Nixon.' And whatever the subject [when I gave a] talk, in the question-and-answer periods...someone would...rise to ask what was wrong with Nixon....I would generally reply with something like, 'How much time have you got?'"

November 7, 1968

NIXON'S fierce five o'clock shadow became a trademark signature of Herblock's early caricatures but, urged on by his colleagues at the *Washington Post*, the cartoonist famously gave the newly elected President Nixon a free shave and a fresh start. Old habits die hard, however, and the dark nature Herblock recognized from the start of Nixon's career and drew in his features soon emerged in the Oval Office.

Taped

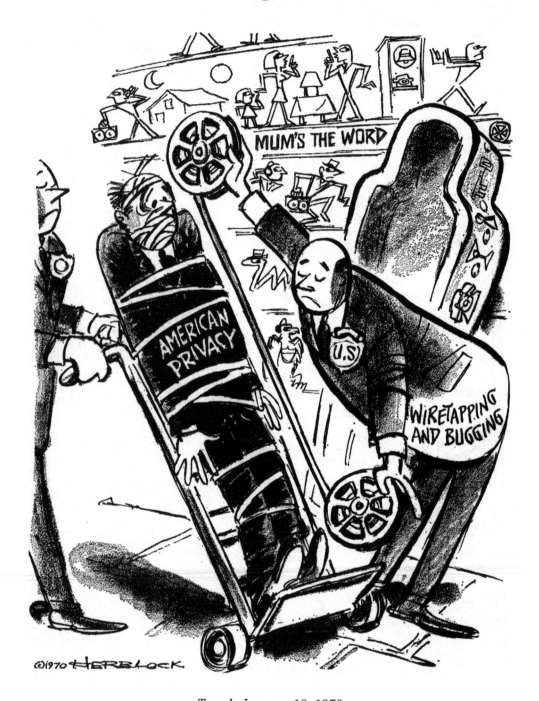

Taped, January 18, 1970

BEFORE the Watergate scandals, Herblock pointed out excessive use of government power to wiretap or otherwise investigate the activities of citizens an administration felt were at odds with its policies. In 1970, the Civil Service Commission admitted to having a Security Investigations Index with over 10 million entries, and the armed forces revealed surveillance of Americans involved in anti-Vietnam war activities.

New Figure On The American Scene

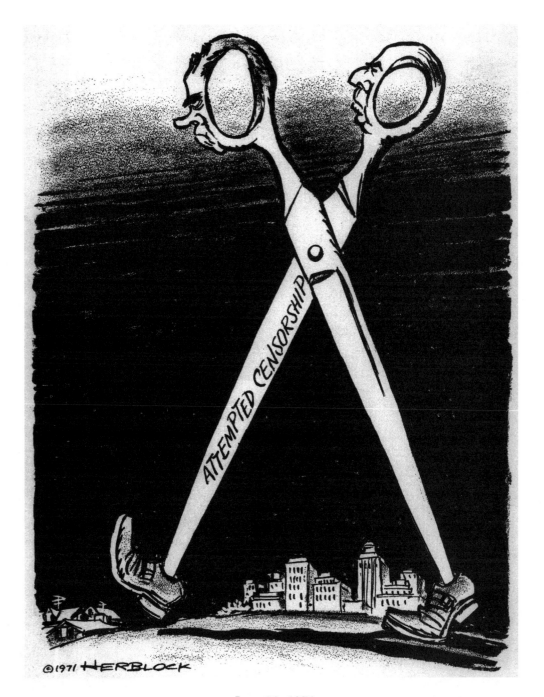

©1971 HERBLOCK

June 20, 1971

ON June 13, 1971, the *New York Times* began publishing installments of the "Pentagon Papers," documents about American involvement in Indochina from the end of World War II to the mid 1960s. The Nixon administration moved to block further publication of the papers, and Attorney General John Mitchell obtained a temporary injunction against the *New York Times*. The Supreme Court rejected the government's request for a permanent injunction.

"Who Would Think Of Doing Such A Thing?"

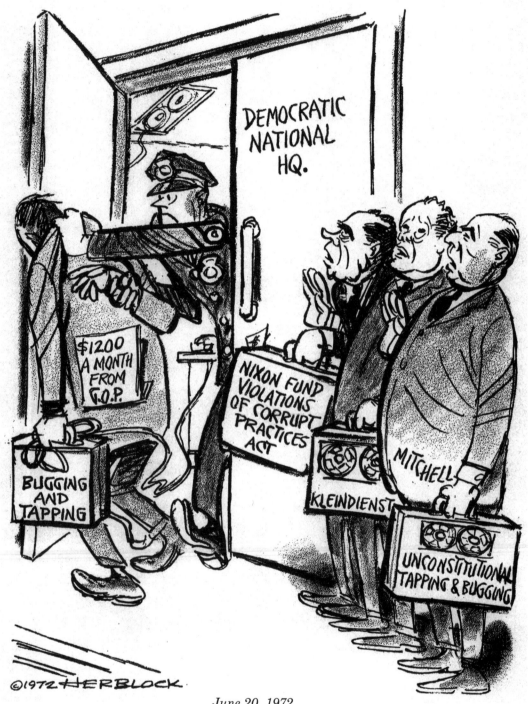

June 20, 1972

TWO days after the *Washington Post* staff writer Alfred Lewis reported that five men were being held in a plot to bug the Democratic National Headquarters at the Watergate building in Washington, D.C., Herblock offered pointed caricatures of Nixon and his two attorneys general— Richard Kleindienst and John Mitchell (then head of the Committee to Re-Elect the President).

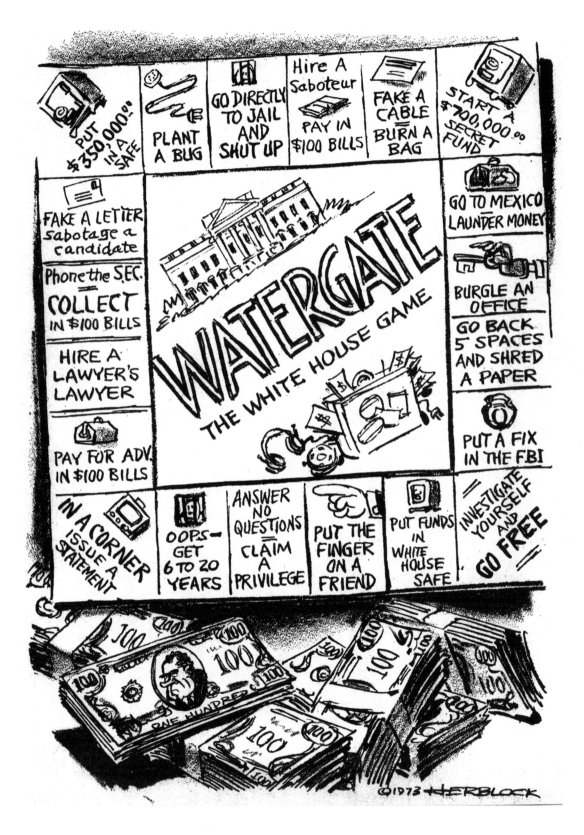

May 1, 1973

National-Security Blanket

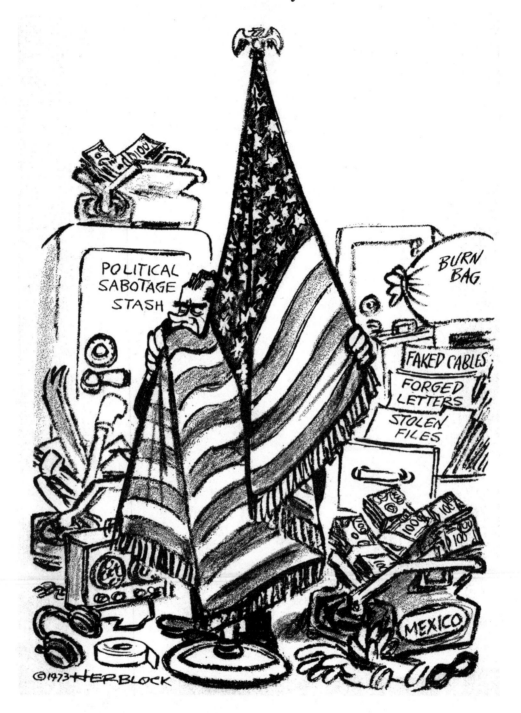

May 27, 1973

ON May 22, 1973, President Richard Nixon admitted that he had concealed aspects of the Watergate case. He said he did so to protect national security "operations." Nixon affirmed his innocence, saying he would stay in office. Herblock saw Nixon seeking cover amidst evidence of wiretapping, break-in, political sabotage, laundered FBI funds from Mexico, and other illegal activities.

"I Am Authorized To Say, 'What Whale?'"

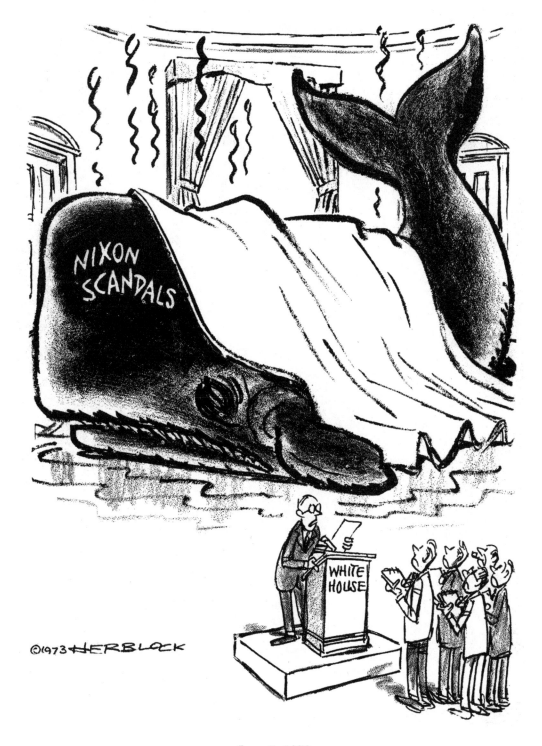

June 5, 1973

THE Nixon White House raised stonewalling to an art, building and reinforcing what former *Washington Post* executive editor Ben Bradlee has recently termed a contemporary "culture of lying."

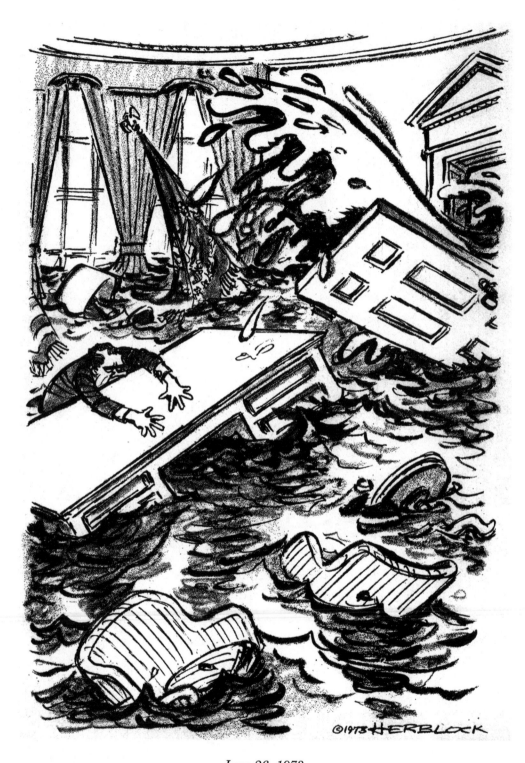

June 26, 1973

BY June 1973, the country had become transfixed by the investigation of Watergate via the televised hearings of the Senate Select Committee on Presidential Campaign Activities. On June 25, former presidential counsel John Dean began his testimony, the first before the committee to directly accuse President Richard Nixon of involvement in the coverup.

"Here I Am, Copper"

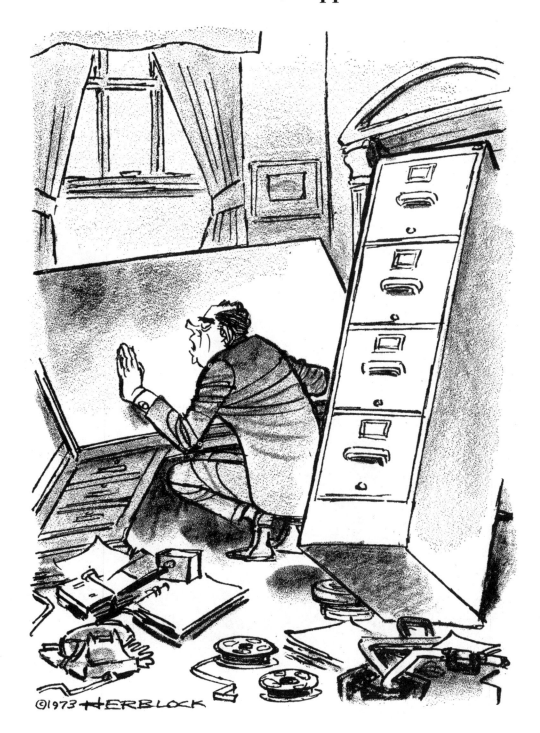

July 27, 1973

AFTER President Richard Nixon refused to turn over tapes alleged to contain conversations about Watergate to Special Prosecutor Archibald Cox, Nixon claimed that "executive privilege" allowed him to keep the tapes private. His position set the stage for court battles.

Mugging

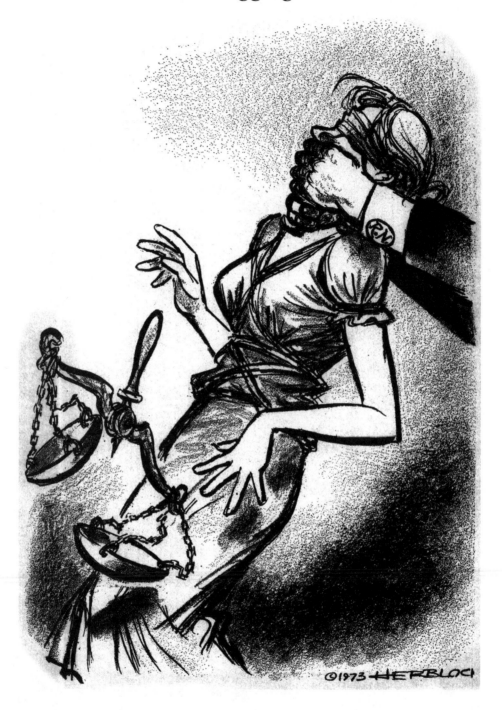

October 23, 1973

ERBLOCK was a thorn in Richard Nixon's side from the politician's House reelection campaign in 1950 to his resignation as president of the United States in 1974. This image of "Justice" assaulted appeared on October 23, 1973, in the midst of the Watergate scandal, just days after President Nixon ordered the firing of special prosecutor Archibald Cox, who was investigating White House activities.

"Move Over—We Can't Stay In A Holding Pattern Forever"

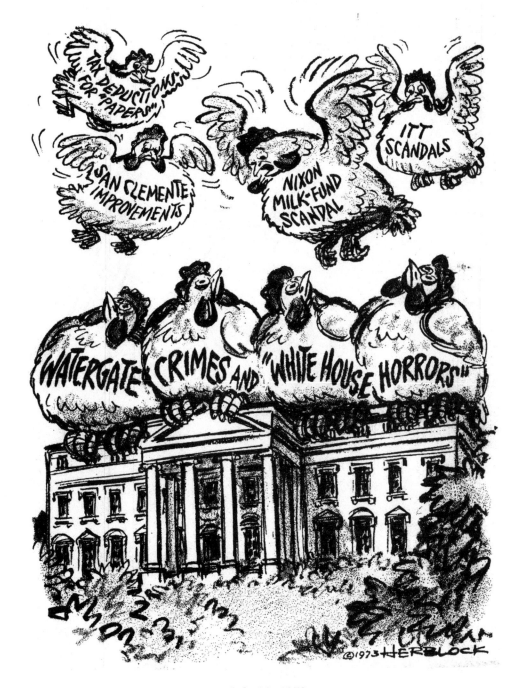

July 29, 1973

HERBLOCK noted other Nixon scandals besides Watergate, including reports of improper influence by ITT Corporation on the location of the future Republican National Convention and disclo-sures of taxpayer money spent to fix up Nixon's homes in Key Biscayne, Florida, and San Clemente, California.

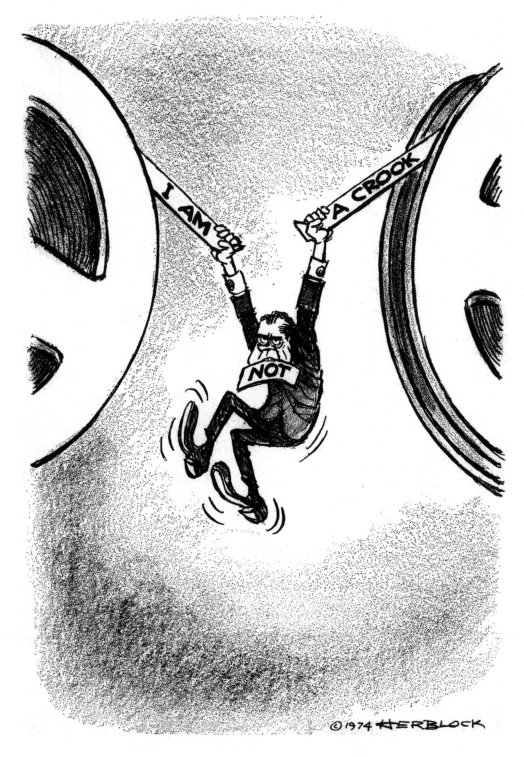

May 24, 1974

EVEN more damning than President Richard Nixon's profiting from public office were the disclosures of his corruption and attempts at corruption of the government itself, including the CIA, the FBI, the Pentagon and even the Secret Service.

A taping system that had recorded most of President Nixon's conversations provided the "smoking gun." Nixon refused to release the tapes until the Supreme Court ordered him to do so.

"We Broke The Law? We <u>Are</u> The Law!"

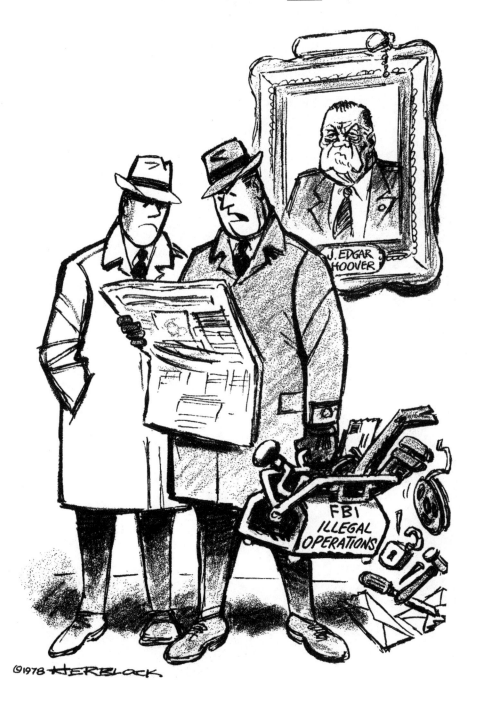

April 16, 1978

J. Edgar Hoover was appointed director of the Bureau of Investigation in 1929; it soon became known as the F.B.I. The legendary lawman kept his post for nearly 50 years, capturing countless crimi- nals, yet also creating controversy by abusing his power, compiling millions of secret dossiers on American citizens, and overstepping his authority to harass political dissenters and activists.

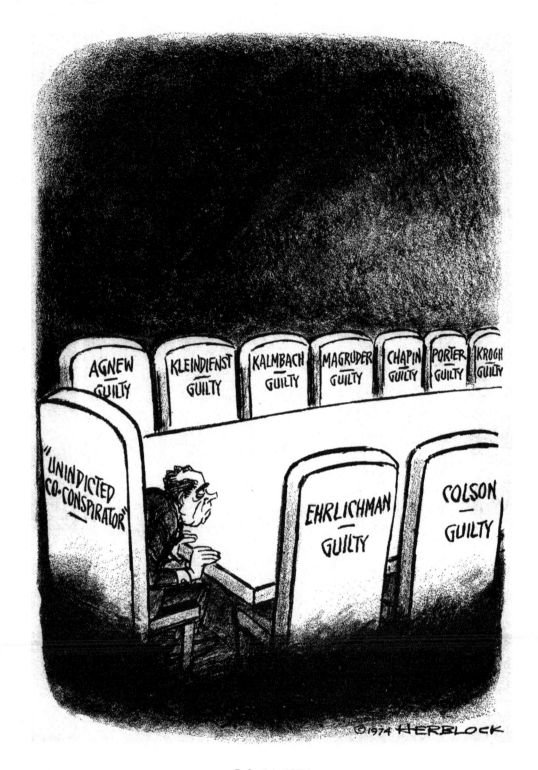

July 14, 1974

BY July 14, 1974, President Richard Nixon stood almost alone. Many of his closest aides had been convicted of illegal activities and he was named an "un-indicted co-conspirator" by the Watergate grand jury. The House Judiciary Committee recommended impeachment, and the Supreme Court required him to turn over all subpoenaed tapes. When even his closest friends agreed that the evidence against him was overwhelming, Nixon bowed to the inevitable, resigning on August 9.

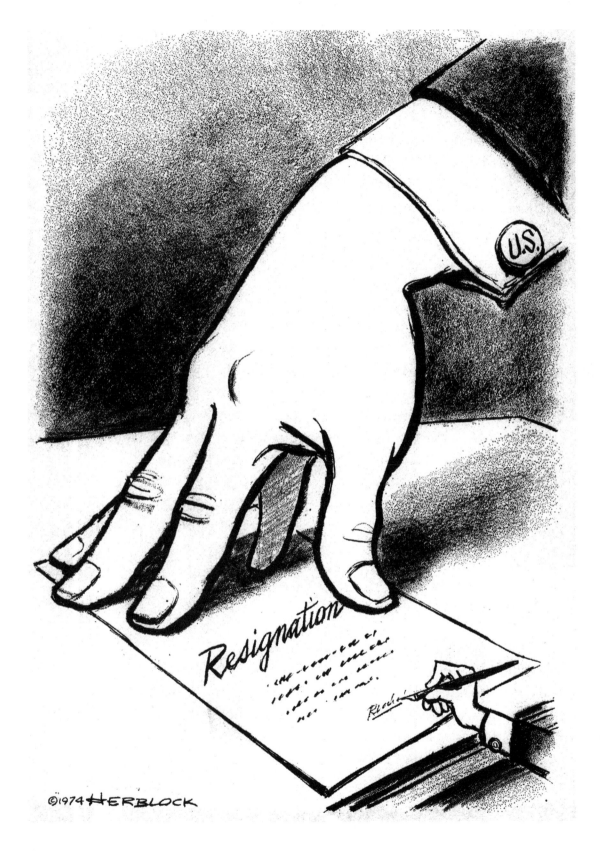

August 9, 1974

The Rise of Terrorism

For Americans, the age of terrorism did not begin with the shocking attacks of 9/11 on New York's World Trade Center. It started a generation before with the seizure of American hostages in Iran by the followers of Ayatollah Khomeini at the end of the 1970s. Once again, we see Herblock's gift for capturing the menace of a dictator: the dark glowering look of Khomeini, the murders carried out on his orders, the suppression of rights, the spread of a reign of terror. The hostage crisis affected the outcome of the 1980 election with Ronald Reagan's defeat of Jimmy Carter. In time, that crisis led to the greatest political crisis of the Reagan presidency: his authorization of trading arms for hostages in what was called the Iran-Contra scandal.

What we see in this section is something more than the fear engendered by terrorism. It is a picture of an America, and American leaders, also being held hostage by their dependence on foreign oil. Herblock's cartoon of November 15, 1979, showing a blindfolded USA entwined by a gasoline line before a pump labeled "U.S. Govt. Failure to End Dependence on Foreign Oil" is even more timely decades later than it was then. Herblock kept emphasizing that theme, reminding readers of how the OPEC oil monopoly affects every aspect of America's foreign policy, defense, trade, inflation, and transportation as well as its politics. He portrays a hapless Jimmy Carter trying to build public support for an energy policy that will free the United States from that dependence but never succeeding in doing so. Another cartoon drives home that point by showing a figure labeled "U.S." with his head buried in the sand. Imprinted on his rear end is the mark of a footprint placed there by oil barons. Herblock's U.S. holds a sign saying "Gently Please" to his adversaries, while in the background a coterie representing OPEC oil countries gleefully watches America's distress.

The oil cartel isn't Herblock's only device to capture the problems of the new age of terror. He portrays controversial leaders such as Cuba's Fidel Castro overseeing a flood of refugees attempting to flee that island by small boats, Mideast terrorists imposing their will on citizens by gunfire and intimidation, and terrorists intruding upon the supposedly peaceful events of the 1980 Olympics. But of all these strong images, the reader is urged to examine carefully Herblock's cartoon of March 20, 1975. This one shows U.S. Secretary of State Henry Kissinger carrying a box filled with nuclear materials, preparing to hand it over to the shah of Iran. In the background missiles labeled "Made in USA" are in place before towering oil derricks. The missiles represent still more gifts from an America to a Middle Eastern oil state. The kicker for this cartoon shows a person representing the United States tapping Kissinger on the shoulder and asking, "Explain Slowly—What Does He Need All Those Weapons For, and Why Does He Need Nuclear Reactors?" That cartoon became even more timely as the United States grappled with the serious dilemma of a nuclear-armed Iran more than thirty years later.

November 13, 1975

ON November 13, 1974, chairman of the Palestine Liberation Organization Yasser Arafat appeared before the U.N. General Assembly dressed in his revolutionary garb, wearing a handgun holster at his hip. Calling for Palestinian self-determination, he denounced Israel and concluded his address with an undisguised threat of future conflict. One year later, on November 10, 1975, the U.N. Assembly granted the PLO observer status.

"Explain Slowly—What Does He Need All Those Weapons For, And Why Does He Need Nuclear Reactors?"

March 20, 1975

HERBLOCK drew secretary of state Henry Kissinger delivering a box of nuclear material to Iranian Shah Mohammad Reza Pahlavi. In 1975, the United States signed a cooperative agreement with then-ally Iran, permitting the U.S. to sell nuclear energy equipment to the Middle Eastern country. Herblock questioned why Iran needed nuclear technology when it was so rich in oil.

"It Helps Maintain A Better Balance"

January 28, 1975

THE administration of President Gerald Ford (1974–1977) also was involved in arms sales to the Middle East.

Energy Policy

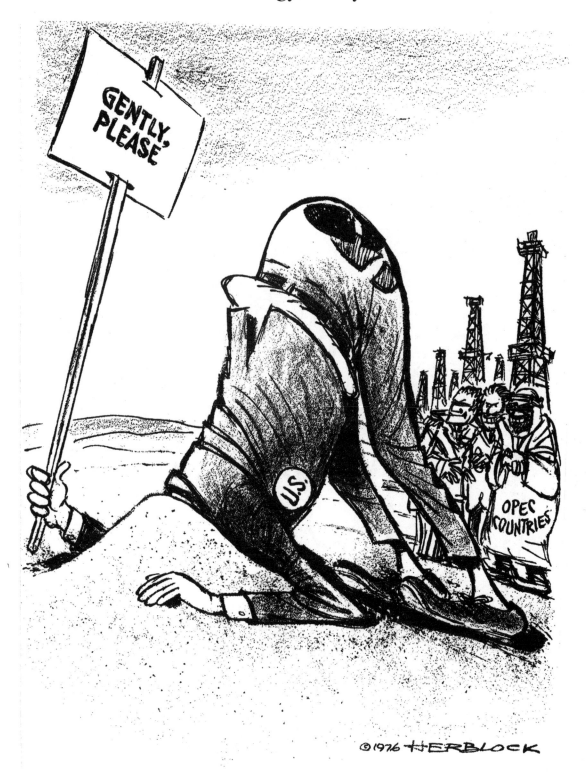

May 28, 1976

Special Invitation

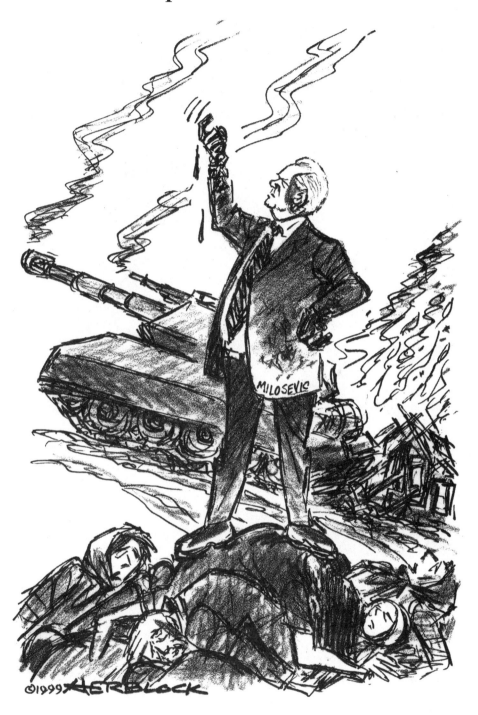

March 24, 1999

I N February 1999, president of Yugoslavia Slobodan Milosevic, a.k.a. "The Butcher of the Balkans," was charged with war crimes and genocide by the International Court of Justice in The Hague, Netherlands. On March 12, Sylvia Poggioli of National Public Radio reported: "Under Milosevic's watch, more than one million people were thrown into prison or forced to flee throughout the Balkans."

Military Escort

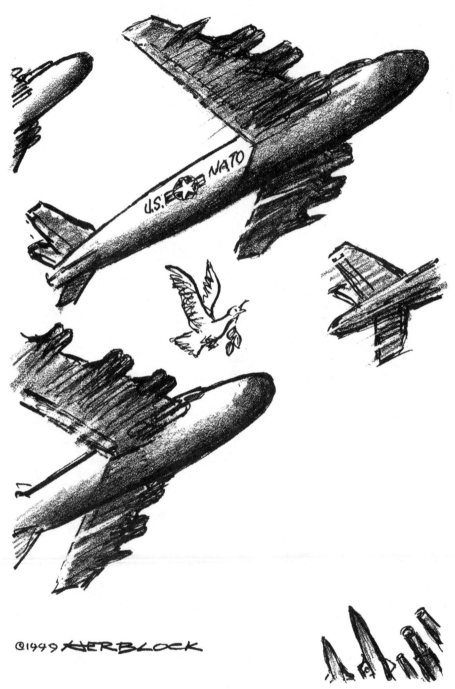

@1999 HERBLOCK

June 6, 1999

IN March 1999 NATO aircraft began the systematic bombing of Serbian army positions within the breakaway Republic of Kosovo. The NATO bombing campaign, which included sorties by American and European aircraft, lasted through May, finally compelling Yugoslavian President Slobodan Milosevic to agree to the presence of an international peacekeeping force within Kosovo on June 12, six days after this Herblock cartoon appeared.

"The Fog Begins To Lift A Little"

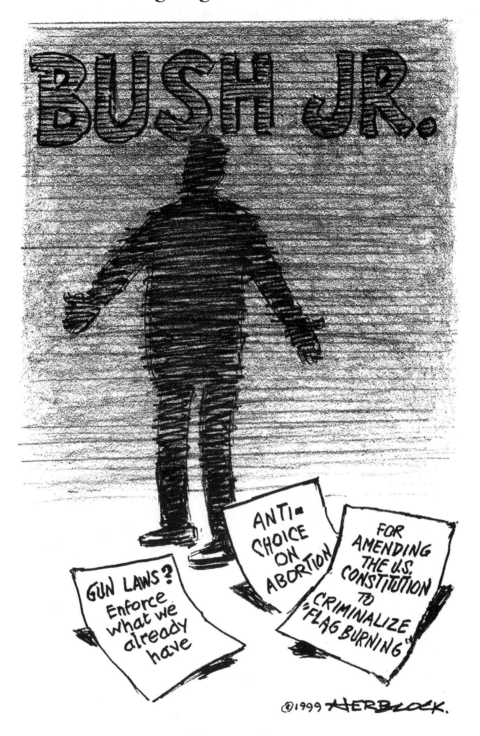

February 4, 2000

DURING the 2000 presidential campaign, Texas governor George W. Bush was a relatively unknown quantity, aside from his avowed conservative and religious fundamentalism. As the campaign waxed, Herblock said, the fog obscuring his values, beliefs and character began to lift.

"'A House Divided'—'Preserve The Union'—When Does He Get To The Important Thing—Telling Us All About His Personal Religion?"

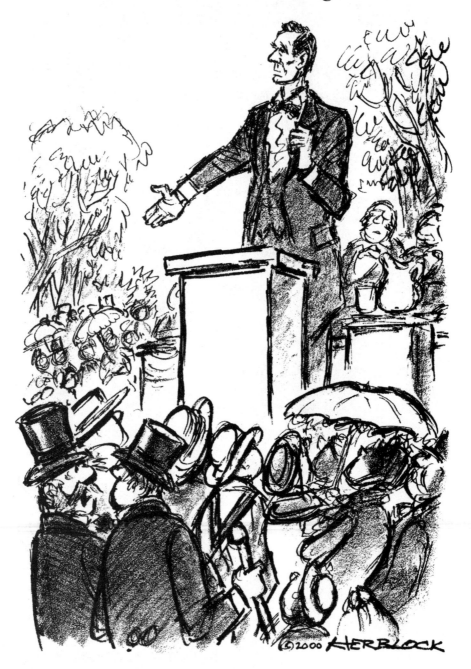

February 10, 2000

PERSONAL religion had become a central issue during the 2000 presidential campaign, as most candidates had announced their religion and their beliefs. In this cartoon, Herblock contrasts today's candidates with Abraham Lincoln, a man who could quote the Bible, but who kept his religious preferences to himself.

"You Can Believe It Because I'll Simply Decide That's How It Will Be"

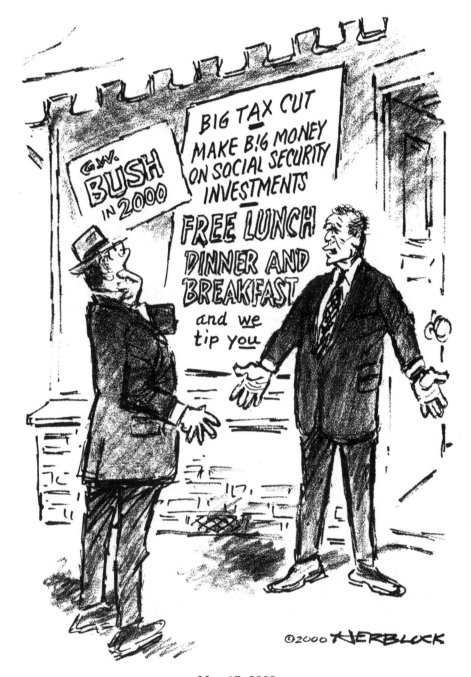

May 17, 2000

H ERBLOCK drew this cartoon of George W. Bush during the 2000 presidential campaign, *six years* before President Bush said the following while defending his embattled secretary of defense Donald Rumsfeld in April 2006: "I hear the voices, and I read the front page, and I know the speculation. But I'm the decider, and I decide what is best. And what's best is for Don Rumsfeld to remain as the secretary of defense."

"Our CEO Is A Genius—He Laid Off A Thousand $10,000-A-Year Employees And Increased His Salary Another 10 Million"

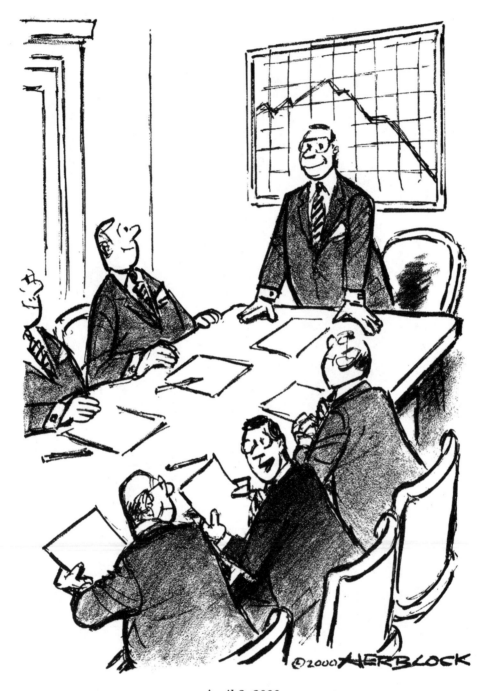

April 2, 2000

ACCORDING to *Forbes* magazine, leading executives from the nation's top five hundred companies earned $6.4 billion in 2007, an average of $12.8 million apiece. Profits continued to rise through such tactics as downsizing and outsourcing which raised the bottom line while lowering salaries and benefits for most lower-level employees.

Getaway Car

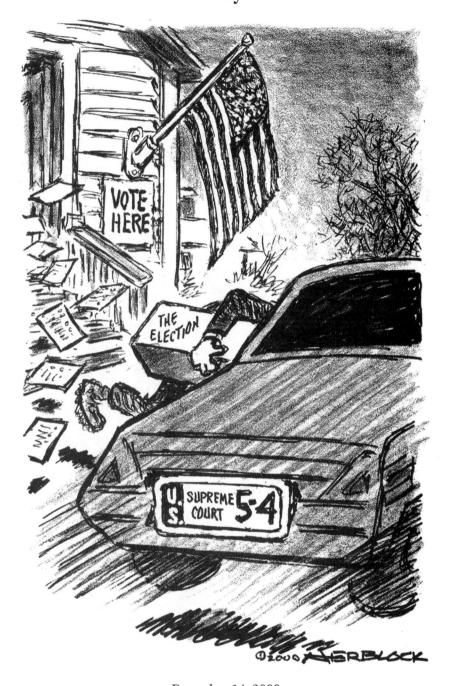

December 14, 2000

IN the early morning hours of November 7, 2000, Republican presidential candidate George W. Bush pulled ahead and the Democratic candidate, Al Gore conceded, then shortly retracted his concession upon hearing from aides that Bush's lead had diminished. By November 8, Bush led Gore by less than 2,000 votes, forcing a recount and weeks of legal maneuvering. Since victory in Florida would decide the election, a month-long review of the balloting and recount ended with a U.S. Supreme Court decision on December 12 in favor of the Bush lawyers, sealing his win.

"Drill The Wilderness! This Is An Energy Crisis!"

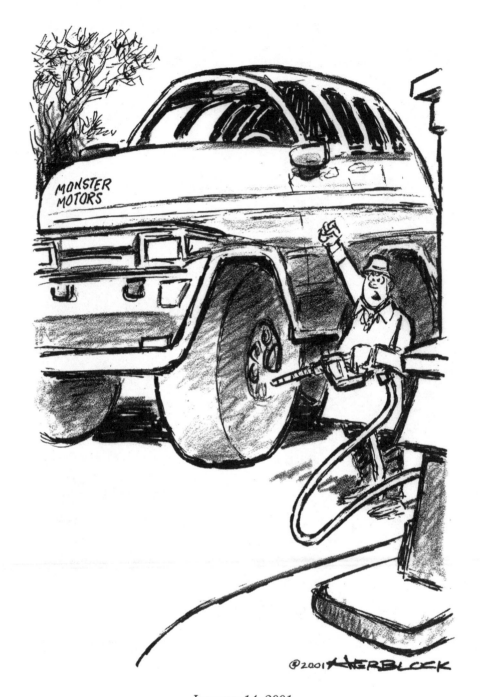

January 14, 2001

MASSIVE gas-guzzling automobiles, called Sport Utility Vehicles or SUVs, dominated American roads during the 1990s and early 2000s. Converted from their early off-road conception to mainstream family transport, SUV's quickly eclipsed station wagons and pick up trucks as standard vehicles for multi-purpose work and recreation. Their high gas consumption, and rising oil prices, however, left some owners feeling the economic crunch and calling for relief, as Herblock notes—with little sympathy.

"He Thought It Would Be A Nice Addition"

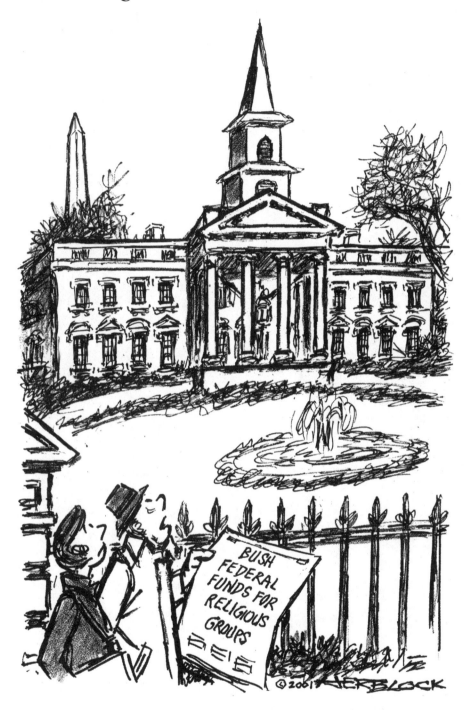

February 9, 2001

HERBLOCK saw the separation of church and state as a fundamental principle of American democracy. In February 2001, this imaginative rendering of the executive residence expressed his displeasure at U.S. President George W. Bush's creation of the White House Office of Faith-Based and Community Initiatives.

"We've Checked It Out—There's No Way Those Polar Ice Caps Are Going To Melt And Flood Our Coasts During Your Administration"

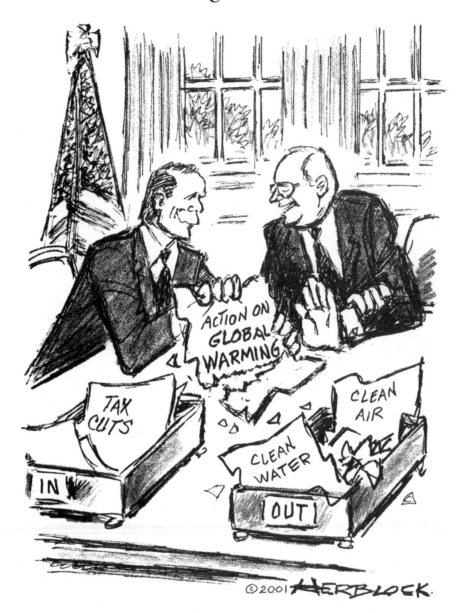

June 3, 2001

SHORTLY after his first inauguration as president of the United States in early spring 2001, George W. Bush announced the government's withdrawal from the Kyoto Protocol, part of an international environmental treaty on global warming created under United Nations auspices. Convinced that business and energy interests given voice by Vice President Dick Cheney influenced the president to pull out of the accords, Herblock's cartoon suggests a more cynical political agenda than that suggested in an address given nine days later by President Bush, who stated, "The Kyoto Protocol was fatally flawed in fundamental ways."

"Call Horace Greeley and Joe Pulitzer And The Rest, And Tell Them She's Here"

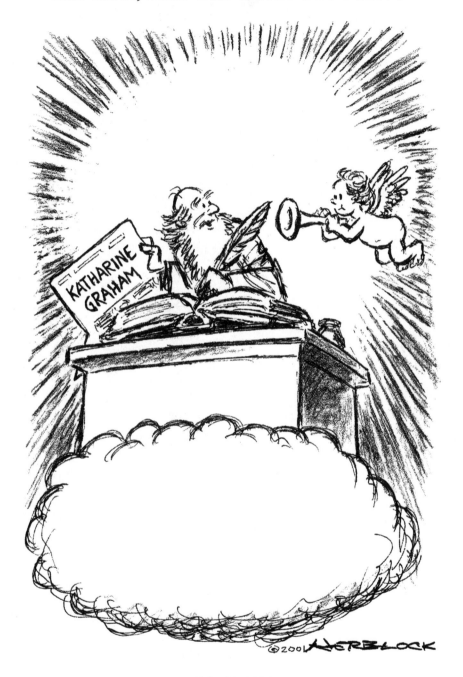

July 18, 2001

IT would be hard to suggest who admired who more, Herblock or Katharine Graham, for whom he worked for almost forty years. Taking over the *Washington Post* upon her husband Phil's death, she built the newspaper into one of the world's great media empires and in the process became a role model for successful working women, and men for that matter. She always stood by Herblock, never censoring his work.

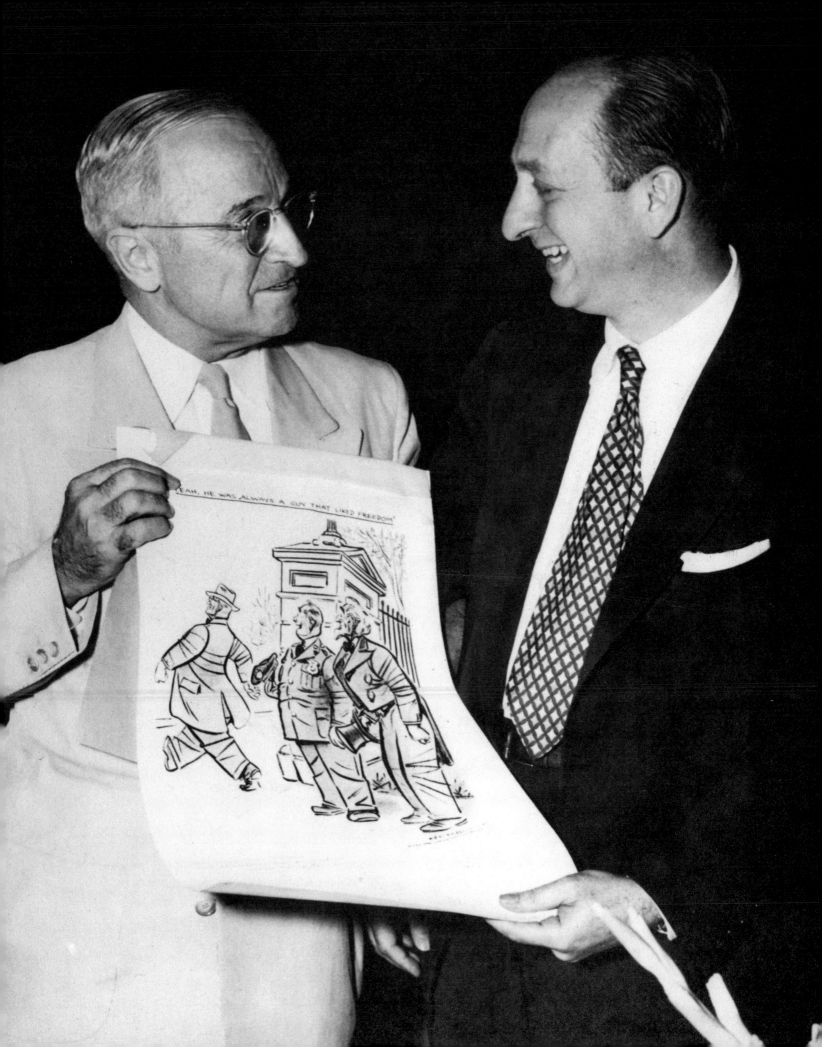

WRITINGS BY HERB BLOCK

The Cartoon

IN one of Charles Schulz's *Peanuts* strips, Lucy announces that she's going to be a political cartoonist "lashing out with my crayon." Just as Charlie Brown asks who will be the subject of her work, she strikes the paper with such a bold stroke that it snaps her crayon in half. "I'm lashing out," she says, "at the people who make these stupid crayons."

I don't believe in the Lucy method of deciding first to "lash out" and then picking a convenient target. But as a person with definite opinions, she might have done well to stick with cartooning anyhow.

A WIDE range of work comes under the heading of editorial or political cartooning today, including gag cartoons on current topics. I enjoy many of these and usually put some fun into my work. But I still feel that the political cartoon should have a view to express, that it should have some purpose beyond the chuckle. So what I'm talking about here is the cartoon as an opinion medium.

The political cartoon is not a news story and it's not an oil portrait. It's essentially a means for poking fun, for puncturing pomposity.

CARTOONING is an irreverent form of expression, and one particularly suited to scoffing at the high and the mighty. If the prime role of a free press is to serve as critic of government, cartooning is often the cutting edge of that criticism.

"All Right Now, Team—Heads Up—
We Can Win This Old Ball Game"

September 5, 1968

SOMETIMES Herblock appropriated the style of *Peanuts* comic strip creator Charles M. Schulz to create his daily cartoon. Herblock greatly admired Schulz and always acknowledged his debt. This cartoon features Democratic Vice-President Hubert H. Humphrey in the role of Charlie Brown rallying his teammates during a baseball game, an allusion to Humphrey's campaign for the presidency that fall against Republican candidate Richard M. Nixon.

WE seldom do cartoons about public officials that say: "Congratulations on keeping your hands out of the public till," or "It was awfully nice of you to tell the truth yesterday." Public officials are *supposed* to keep their hands out of the till and to tell the truth. With only one shot a day, cartoons are generally drawn about officials we feel are *not* serving the public interest. And we usually support the "good guys" by directing our efforts at their opponents.

For people who think political cartoons are inclined to be negative, a good explanation is in the story of the school teacher who asked the children in her class to give examples of their kindness to birds and animals. One boy told of how he had taken in a kitten on a cold night and fed it. A girl told of how she had found an injured bird and cared for it. When the teacher asked the next boy if he could give an example of his kindness to nature's creatures, he said, "Yes ma'am. One time I kicked a boy for kicking a dog."

In our line of work, we frequently show our love for our fellow men by kicking big boys who kick underdogs. In opposing corruption, suppression of rights, and abuse of government office, the political cartoon has always served as a special prod—a reminder to public servants that they *are* public servants.

That is the relationship of the cartoonist to government, and I think the job is best performed by judging officials on their public records and not on the basis of their cozy confidences.

Greatest Country On Earth

July 23, 2000

IN the summer of 2000, on the cusp of a new millennium, Herblock asked his legion of devoted readers to consider that for all its advantages the United States, the world's richest, most powerful nation must continue to address its most pressing political, social and economic problems.

As for the cartoonist's relationship to the rest of the newspaper, that depends on the individual cartoonist and the paper. The editorial page cartoon in the *Washington Post* is a signed expression of personal opinion. In this respect, it is like a column or other signed article—as distinguished from the editorials, which express the policy of the newspaper itself.

Other newspapers operate differently. On some, the cartoon is drawn to accompany an editorial. The cartoonist may sit in on a daily conference, where the content of editorials and cartoons is worked out. Or he may be given copies of the editorials before publication.

A completely different arrangement is followed when the cartoonist simply sends in his work, sometimes from another city. Still other variations include cartoonists submitting sketches (one or several) for editorial approval.

I draw my cartoons at the *Washington Post*, but don't submit sketches or sit in on editorial conferences. And I don't see the editorials in advance. This is for much the same reason that I don't read "idea letters." I like to start from scratch, thinking about what to say, without having to "unthink" other ideas first. That's something like the old business of trying *not* to think of an elephant for five minutes. It's easier if nobody has mentioned an elephant at all.

In my case, the actual work process is more methodical than inspirational—despite the apparent aimlessness of strolls out of the office, chats with friends, shuffling papers, lining up drawing materials and other diversions that may or may not have to do with creativity. It's methodical compared to the popular impression that "getting an idea" consists of waiting for a cartoon light bulb to flash on overhead.

THE day's work begins with reading the newspapers, usually starting the night before with the first edition of the *Washington Post*, and making notes on possible subjects. I also flip on the radio or TV for late news developments. This practice began when I was just about to turn in a finished cartoon one day, only to learn that a major story had broken and kept the newsroom people too busy to tell me about it. The quick return to the drawing board to produce a new cartoon in minutes was an experience I wouldn't want to repeat. And with broadcast reports on the hour or even the half hour, I now occasionally pass along late-breaking news to others.

Unless there is one subject of overriding importance or timeliness on a particular day, or some special outrage, I generally try to narrow down the list of subjects to two or three. Next comes the business of thinking about what it is that needs to be said—and then getting the comment into graphic form, which involves drawing several rough sketches.

IT is hard to say just when a thought turns into a cartoon. In writing or speaking, we all use phrases that lend themselves to visual images. Where you might say that a politician is in trouble up to his neck, a drawing might show him as a plumber in a flooded basement or a boy at the dike with his chin just above the water line. On one occasion when a public figure obviously was not telling the truth, I did a sketch of him speaking, with a tongue that was shaped exactly like a table fork. These are pretty simple examples, but they may provide some clue to how concepts develop into drawings.

"We'll Let The Overcoat Out All The Way, And The Robe Will Hardly Show At All"

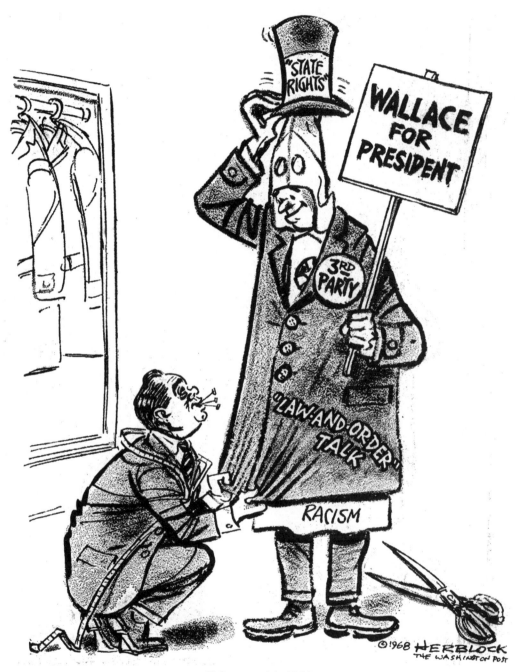

February 11, 1968

GOVERNOR George Wallace of Alabama had achieved national notoriety when he defied federal orders to integrate the University of Alabama in 1963, and he continued to fan the fires of racial intolerance. In 1968, he tried to capitalize on continuing resentment over civil rights measures beyond the South by running for president on a third party ticket. In November, he received the electoral votes of only five Southern states.

"Very Nice—For People Who Believe In That Kind Of Thing"

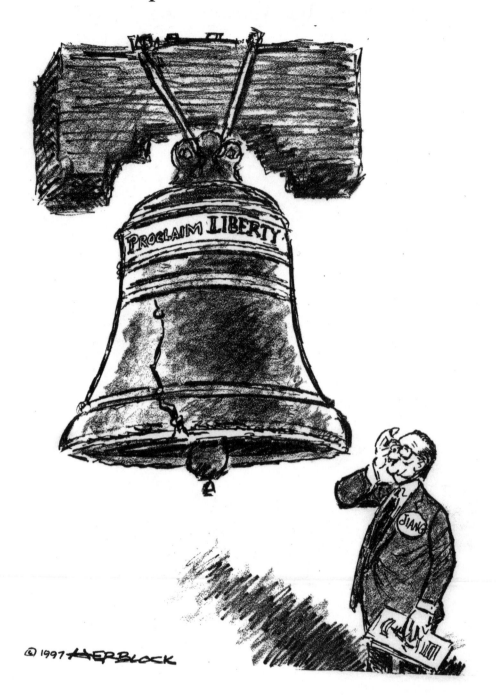

October 30, 1997

CHINESE President Jiang Zemin's late October 1997 visit to the United States was the first trip to America by a Chinese leader since 1979. China's subjugation of Tibet, violent response to the Tiananmen Square protests, ongoing suppression of political dissent, and suppression of free speech and a free press left many observers skeptical of the government's willingness to reform its views on human rights.

I T may not sound very exciting or "cartoony," but to me the basic idea is the same as it ought to be with a written opinion—to try to say the right thing. Putting the thought into a picture comes second. Caricature also figures in the cartoons. But the total cartoon is more important than just fun with faces and figures.

I mention this because it is a common conversational gambit to ask cartoonists if they're having a good time with some well-known face. And when media people are doing articles on a new political personality, they often phone cartoonists to ask what it is about the politician's features that grabs them. Some even ask which candidate you would like to see elected on the basis of "drawability." That's like asking a writer what person he wants elected on the basis of whether the candidate's name lends itself to puns.

I HAVE not yet yielded to the temptation to answer such questions by saying I liked Ronald Reagan's right ear lobe or Jimmy Carter's left nostril. Actually, anyone can be caricatured. And if a cartoonist needed a public figure with Dumbo-the-Elephant ears or a Jimmy Durante nose, he'd have to be pretty hard up for ideas *and* drawing.

FROM time to time the question of cartoon fairness comes up—with some practitioners asserting that they are not supposed to be fair. This is a view I don't share. Caricature itself is sometimes cited as being unfair because it plays on physical characteristics. But like any form of satire, caricature employs exaggeration—clearly recognized as such. Also the portrayal of a person is often part of the opinion. For example, President George [H.W.] Bush was associated with words like "Read my lips" and "The vision thing." Emphasizing his overhanging upper lip and squinty eyes expressed a view identifying him with his words. I think fairness depends on the cartoon—on whether the view is based on actual statements, actions or inactions.

Questions of fairness are not confined to pictures. Some broadcasters and columnists regularly earn championship belts for fighting straw men. (Those "liberals" want the government to take all your money and run your lives in Washington. Those "conservatives" want to see your kids starve to death.) Incidentally, I would like to see a better word than "conservative" for some who are not eager to conserve basic rights or the environment.

A COLUMNIST who opposes political campaign funding reform—based on his interpretation of the First Amendment—wrote a piece in which he pointed out that we spend more on potato chips than on political campaigns. But if true, the purchase and consumption of potato chips, whatever they do to our diets, can hardly be compared to the purchase and corruption of public offices. I'd guess the columnist who reached for that statistical irrelevance probably regards cartoons for campaign funding reform as "gross caricatures."

"You Russians Have To Pull Up Your Socks"

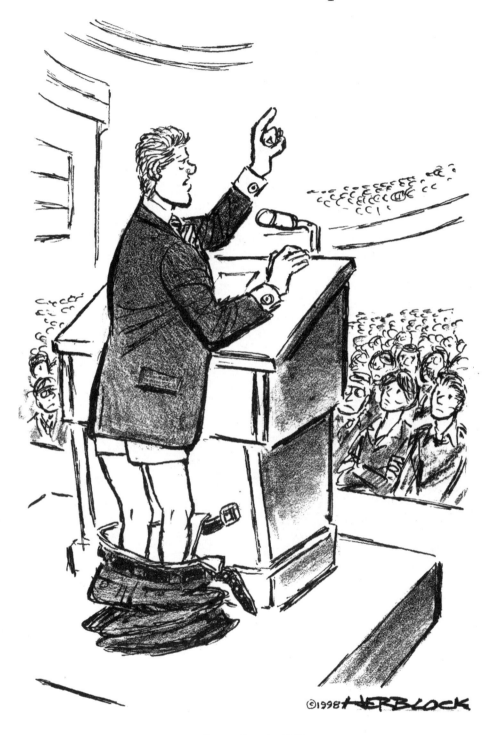

September 2, 1998

HERBLOCK suggests that with his pants pulled down figuratively, and literally, by such domestic scandals as the Monica Lewinsky and Paula Jones episodes, President Bill Clinton had little credibility when lecturing foreign leaders on their behavior.

The Sorcerer's Apprentice

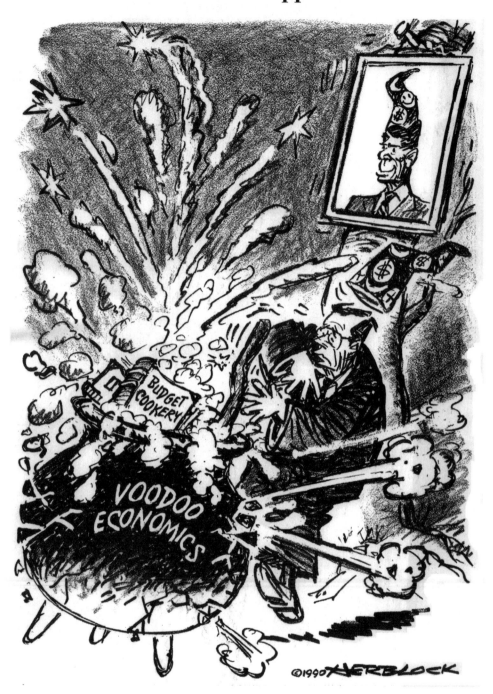

October 7, 1990

GEORGE Bush ran against Ronald Reagan for the Republican nomination during the 1980 presidential campaign, criticizing his opponent's economic program as "voodoo economics." Herblock comments: "Later, on being considered for the vice presidency, he not only switched to supporting Reagan's economic policies...he got the job. And four years later, The Big Job. But his 1988 pledge, 'Read my lips. No new taxes' came back to bite him when he agreed to a budget plan to increase taxes."

BUT back to the drawing board and the sketches—a series of "roughs" may approach a subject from different angles or may be variations on a theme. This is where other people come into the picture—or, more accurately, where I bring the pictures to other people. By showing sketches to a few colleagues on the paper, I often find out which sketch expresses a thought most clearly. The purpose of these trial runs is not only to get individual reactions, but also to get out any bugs that might be in the cartoon ideas.

ONE of the advantages of working at the *Washington Post* is the access to information about government and assorted news items. Reporters, researchers and other staff members are available—with special knowledge about subjects they have dealt with. They also know where to find answers to questions about who said what or exactly what happened when. And computers now make it possible to recall statements and records of all kinds.

A SKETCH on arms programs or military costs, for example, is one I'd particularly want to discuss with the Pentagon correspondent. A writer covering the courts can tell me if I've missed anything in a decision. Capitol Hill writers, familiar with the exact status of congressional bills, can tell if a sketch on a piece of legislation is well-timed. Staff members may also have information that helps me decide which cartoon is the best bet for that day. Such help—not "ideas for cartoons," but background information and relevant facts—is of enormous value.

I'M a deadline pusher, and one reason the finished cartoon is usually a last-gasp down-to-the-wire effort is because of the time spent on sketches. I work on them as long as possible. And after deciding on one, I send a Xerox copy of it to the editor's office.

Other cartoonists—as well as other papers—prefer different arrangements. One cartoonist told me he had tried for years to get the kind of freedom I have on the *Post*. When he finally got it, he found the decision-making to be a burden. He went back to asking an editor to make the daily choice.

I ENJOY the freedom to express my own ideas in my own way. And this is also consistent with the *Washington Post* policy expressed by the late publisher, Eugene Meyer, who said he believed in getting people who knew what they were doing and then letting them do it.

One of the things that has made the *Washington Post* great is the fact that it does provide for differing views instead of offering a set of written and drawn opinions all bearing the stamp of a single person. Over the years, there have been differences between the cartoons and the editorials on issues, on emphasis, and on performances of individual public figures.

In 1952, for example, the *Washington Post* endorsed General Dwight D. Eisenhower for President before either major party had made nominations. The cartoons expressed my unhappiness with the Presidential campaign conducted by Eisenhower, and with his choice for Vice President, Richard Nixon—and expressed my clear preference for candidate Adlai Stevenson.

The Helicopter Era

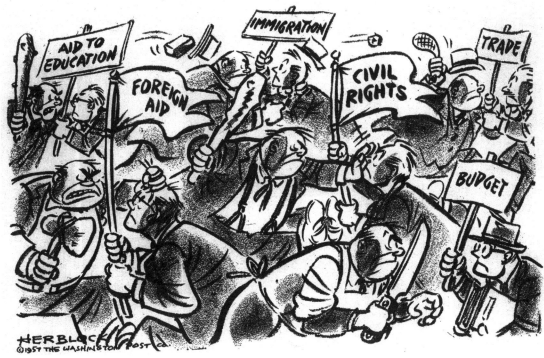

March 27, 1957

"MANY of my drawings of President Eisenhower —when he reported himself as feeling fit and on duty—have shown him in various attitudes of inactivity when problems cried out for attention. It seemed to me that the President, who had often expressed his belief in the principle of separation of powers, too often had separated himself from his own powers," commented Herblock.

Hit

July 1, 1990

HERBLOCK registers through the eyes of a black child the shock and dismay felt by millions of television viewers at the sight of Washington, D.C. mayor Marion Barry, caught on an FBI surveillance video smoking crack cocaine in a hotel room with a former girlfriend, Hazel "Rasheeda" Moore. Arrested on January 18, 1990 in a joint sting operation run by the FBI and D.C. police, Barry's comments were captured on tape: "Goddamn setup...I'll be goddamn. Bitch set me up."

ABOUT 1965, with a different editor and a different publisher, the cartoons focused more and more on President Johnson's "credibility gap" and his escalation of the war in Vietnam, while the editorials generally supported the president and his Vietnam policy. Even on this extremely divisive issue, the editor and I respected each other's views.

Later, the cartoons and editorials diverged on other subjects. For example, in the 1970s I did a series of cartoons opposing the confirmation of Clement Haynsworth to the Supreme Court—a view not shared in the editorials. But we were in agreement in opposing the next nominee— G. Harold Carswell.

DURING the Clinton administration I did not share in the *Post*'s approval of the expansion of the North American Treaty Organization (NATO) after the collapse of the Soviet Union. And the cartoons hardly matched the editorials on Independent Counsel Kenneth Starr—which acknowledged that he had made mistakes in the probe of President Clinton's relationships but saw him as a victim of a vicious organized attack.

On important issues involving civil rights and civil liberties the editorials and cartoons have been in general agreement. There was no possible doubt about the stands they shared on the attempted censorship involved in the publication of the Pentagon Papers on Vietnam, or the culmination of the Nixon scandals in Watergate. And they have both been involved in the long continuous battles for campaign finance reform, and gun control, and tobacco industry curbs.

BUT even where the general viewpoints have been the same, there have been times when I knew a publisher or editor would have preferred my using a different approach. During the Watergate disclosures, I did a "naked Nixon." This might have seemed like *lèse majesté* to an editor but was *au naturel* for a cartoonist.

I'VE often summed up the role of the cartoonist as that of the boy in the Hans Christian Andersen story who says the emperor has no clothes on. And that seemed to be just what was called for during this phase of the "imperial presidency."

WHAT a written piece can do more easily than a cartoon is to comment on a subject that requires giving background information. Wordiness can be awkward in a cartoon—though words are sometimes needed to explain an issue or provide dialogue. But a cartoon at times can say something that might be harder to put into words. The one of Nixon hanging between the tapes comments not only on his situation at the time, but on his veracity and honesty—without using any words other than his own.

Bubble Dance

June 6, 1974

TWO months before Richard Nixon resigned the presidency, Herblock drew this cartoon. Herblock wrote: "I've often summed up the essential role of the political cartoonist as being that of the kid in the Hans Christian Andersen story who says, 'The emperor has no clothes on.' For a long time after the Watergate break-in, it seemed to be a matter of saying, 'Good grief, none of that bunch has any clothes on.'"

Gandhi

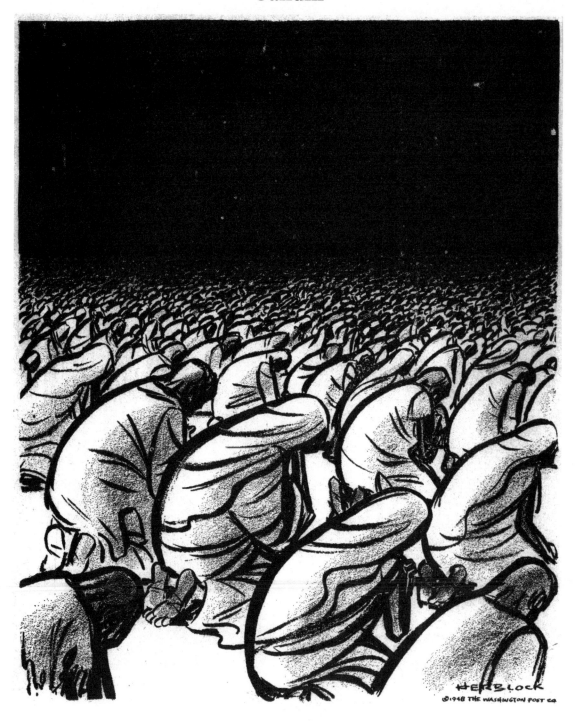

January 31, 1948

MOHANDAS Gandhi (1869–1948), spiritual and political leader of the Indian independence movement against British rule, inspired millions around the globe with his policy of non-violent civil disobedience in the face of oppressive governmental authority. His followers included Martin Luther King, Jr. in the United States and Nelson Mandela in South Africa.

April 19, 1955

HERBLOCK pays final, admiring tribute to scientist Albert Einstein (1879–1955). In 1932, with the rise of Nazism, Einstein left Germany for America where he participated in the Institute for Advanced Studies at Princeton University. In 1940, settled in New Jersey where he remained to his death, he became a U.S. citizen.

AS for a comparison of words and pictures—each has its role. Each is capable of saying something necessary or something irrelevant—of reaching a right conclusion or a wrong one.

A cartoon does not tell everything about a subject. It's not supposed to. No written piece tells everything either. As far as words are concerned, there is no safety in numbers. The test of a written or drawn commentary is whether it gets at an essential truth.

AS for subject matter, I don't believe there should be any sacred cows. But there's no obligation for the cartoonist to deal with a topic unless he feels there is a point that needs to be made. Regardless of Lucy's view, the object is not to "lash out" just because the means is at hand.

"Rosalynn, It's Him Again"

September 12, 1979

HERBLOCK'S commentary on the 1980 contest for the Democratic presidential nomination recalls a popular contemporary Gillette television commercial showing a two-sided, mirrored bathroom cabinet. On September 11, 1979, Senator Ted Kennedy of Massachusetts announced his intention to run for president against the Democratic incumbent Jimmy Carter unless there was "improvement in the economy." Democratic House Speaker Tip O'Neill encouraged Kennedy to run, which he did unsuccessfully.

THERE is no shortage of subjects for opinions. I don't long for public misfortunes or official crooks to provide "material for cartoons." Hard as it may be for some people to believe, I don't miss malefactors when they are gone from public life. There are more things amiss than you can shake a crayon at.

IF the time should come when political figures and all the rest of us sprout angel wings, there will still be different views on the proper whiteness and fluffiness of the wings, as well as flaps over their flapping, speed, and altitude. And there will still be something funny about a halo that's worn slightly askew.

WHEN that happy heaven-on-earth day comes, I'd still like to be drawing cartoons. I wouldn't want to see any head angel throwing his weight around.

"That's My Boy"

July 15, 2001

WHEN, just weeks before his passing, Herblock drew this chummy caricature of President George W. Bush alongside a gat-slinging NRA lobbyist saying "That's My Boy," he was only echoing the sentiments of Bush's own brother Jeb, quoted at the gun association's annual meeting as attributing the NRA's support for Bush's win.

Auld Lang Syne

See Here, It's Private Herblock Cartooning

June 4, 1943

Major Causes of World Unrest

August 3, 1937

Bailout, 1979

December 7, 1979

THE administration of President Jimmy Carter decided to bail out the financially troubled Chrysler Corporation in August 1979, in order to fend off bankruptcy and loss of jobs. Herblock pointed out that while the Carter administration, Chrysler Corporation and United Auto Workers all reaped benefits from the bailout, the American taxpayers funding the proposal did, in the end, pay the price.